ROLLINS PASS

ROLLINS PASS

B. Travis Wright, MPS, and Kate Wright, MBA

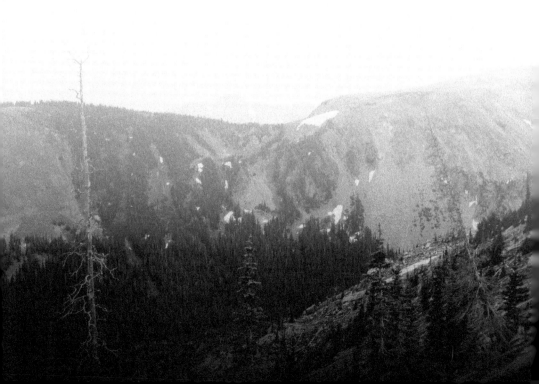

This book is dedicated to those who protected and defended Rollins Pass from a land exchange in 2020–2021—the next seven generations thank you.

Library of Congress Control Number: 2021950579

Published by Arcadia Publishing
Charleston, South Carolina

For all general information, please contact Arcadia Publishing:
Telephone 843-853-2070
Fax 843-853-0044
E-mail sales@arcadiapublishing.com
For customer service and orders:
Toll-Free 1-888-313-2665

Visit us on the Internet at www.arcadiapublishing.com

ON THE FRONT COVER: Perhaps the most well-known story of Rollins Pass is the ambitious railroad route up, over, and down the Continental Divide. However impressive this chapter is, it represents only several decades of the 12,000-year history of this magnificent area. The long arc of the prehistory and history of Rollins Pass encompasses internationally significant Native American game drives, a toll wagon road route, early narrow-gauge railroading attempts, lode and placer mining, aviation and pipeline uses, and a vehicular route. (Both, courtesy of the authors' collection.)

ON THE BACK COVER: A visitor to Rollins Pass penciled a brief postcard on Sunday, August 27, 1922, "I will mail this at the 'Top of the World'. . . . We have gone thru [sic] 32 tunnels, 5 mi. of snow sheds and I have made snow balls. The higher elevation has very little effect on me." For the 25 years rails were used on Rollins Pass, passenger trains were common. Freight trains transported livestock, lumber, and "ores of the precious and allied metals," wrote the *Salida Record*. All trains carried news, gossip, and mail. (Courtesy of the authors' collection.)

CONTENTS

Acknowledgments vii

Introduction ix

1. Sacred Lands: The Paleoindian and Native American 11

2. A Great Gate: Traversing Rollins Pass 15

3. Piercing the Divide: The Moffat Tunnel 85

Bibliography 94

About Preserve Rollins Pass 95

ACKNOWLEDGMENTS

The authors are deeply appreciative of the following individuals and organizations for sharing insight, imagery, and heartwarming stories. This book would not have been possible without Alex Funderburg; Andrea Kirsch; Charles Crocker; Charles Plantz; Dan Micka; Dave Naples, Moffat Road Railroad Museum; Denver Public Library; Erin Courchaine and Cam Breton; George Engle; Gilpin County Historic Preservation Commission; Gregory Dietz; Hope Arculin, Carnegie Branch Library for Local History; Jerome Rose, PhD, University of Arkansas; John Rodden; John Slay Archive, Center for Mountain and Plains Archaeology; Larry Fullenkamp, US Forest Service Archaeology (USFS); Lauren Ransom, law enforcement officer, Arapaho National Forest; Library of Congress; Rich O'Leary; Robert Ornelas; Robert "Bob" Zarlengo; Shanna Ganne, Grand County Historical Association (GCHA); Steve Pott; Thomas Johnson; Tom Jacobs; Tread of Pioneers Museum; Tristan Anderle; and the Zarlengo family.

The Toll and Zarlengo families generously opened their historic, private property to the authors; Travis and Kate also had memorable access to the East Portal of the Moffat Tunnel from Union Pacific Railroad. A deep thank-you to H. Wolcott Toll, Steve O'Dorisio, and the Anderle family. Special recognition for scientific information kindly provided by David Anderson and Susan Panjabi, Colorado Natural Heritage Program, Colorado State University; Cal Ruleman, Geosciences and Environmental Change Science Center, US Geological Survey; Dr. Suzanne Anderson, Department of Geological Sciences and Institute of Arctic and Alpine Research, University of Colorado; Yvette Kuiper, PhD, Department of Geology and Geological Engineering, Colorado School of Mines; William Stone, National Oceanic and Atmospheric Administration's National Geodetic Survey; and Jason M. LaBelle, PhD, Department of Anthropology, Colorado State University. Preservation efforts of Rollins Pass must include a distinctive mention of Kim Grant and Colorado Preservation Inc.; Garrett Briggs, Southern Ute Indian tribe; Amy Webb, National Trust for Historic Preservation; Middle Park Chapter, Great Old Broads for Wilderness; and Holly Norton, PhD, state archaeologist, History Colorado.

Retaking imagery complementary to historic photographs presented a challenge best answered by technology. To illustrate, the 368-foot-long trestle on page 28 no longer exists; commercial unmanned aircraft system (UAS) flights provided the modern-day perspective from the researched and requisite height. All flights complied with Federal Aviation Administration (FAA) regulations under 14 Code of Federal Regulations (CFR) Part 107, and no UAS took off, landed, or were operated from the wilderness. Unless otherwise specified, historic photographs are from the authors' John Trezise Archive for Rollins Pass Imagery collection, while modern shots were photographed by the authors or are part of the authors' collection.

The authors acknowledge and honor the indigenous peoples of the land upon which Rollins Pass stands.

INTRODUCTION

For almost two billion years, the rocks of Rollins Pass were formed and deformed by plate tectonic processes that created mountains and landscapes, the last of which is seen today. Fluffy flakes fluttered from the heavens and were deposited to form glaciers; the fresh snow would, in time, transform into compact and crusty ice with newfound geologic power to alter landscapes. Mountains were subsequently sculpted by both cirque and valley glaciers advancing then retreating many times over. Ice, friction, and intense forces worked the landscape, grinding bedrock and rerouting streams; basketball-sized rocks plucked from under the ice were lodged in lateral and terminal moraines down valley. Glacial erosion produced rock outcrops named roche moutonnée ("rock sheep") for their resemblance to the rounded backs of sheep; they are particularly evident trundling east out of the King Lake basin. A gradual retreat of the ice revealed broad valleys with gently rolling floors dotted with newly formed glacial alpine lakes. As the Pleistocene Epoch ended about 12,000 years ago, glacial retreat accelerated, and the undulating terrain comprising Rollins Pass was revealed as a pristine canvas ready for what was to follow.

One of the earliest known indigenous inhabitants of the Americas, a Paleoindian, was visiting or traversing what would one day be known as Rollins Pass and had fashioned a piece of Troublesome chert to pierce the hide of game. While the success of that day's hunt can never be known, what did endure was the midsection of a Scottsbluff projectile point—professional archaeologists state the existence of this stone tool provides evidence to confirm the use of Rollins Pass more than 73 centuries before the creation of the alphabet.

Periglacial processes, generally associated with permafrost, created blockfields and, with it, angular rock debris. At the highest elevations, Mother Nature had, in a sense, done much of the heavy lifting required—all that remained was for prehistoric hunters to assemble the pieces into what would become a game drive complex unrivaled anywhere in the world. Beginning thousands of years ago, the landscape was modified by human hands; raw materials were realigned to form cairns, walls, and blinds for the purposes of hunting game. Tabular stones were propped and supported by other rocks to create what professional archaeologist James Benedict described as "leaning slabs."

The game drive systems hindered animal movement across the Continental Divide at Rollins Pass to the benefit of the ancient hunters. Migrating animals could no longer transit the pass unscathed—some would perish in the journey to and from the Atlantic and Pacific watersheds. These game drives were continually refined and expanded for thousands of years until the mid-19th century, when Native American use of these systems slowed considerably and effectively ceased.

Beginning in the 1860s, alpine grasses and portions of the rugged landscape were flattened under the weight of horses, cattle, and wagon wheels. John Quincy Adams Rollins constructed a toll wagon road from Rollinsville into Middle Park by way of this pass. Rollins himself reshaped the area further; where a grade between hills was steep, "Mr. Rollins would build a cribbing of logs in this gulch and would fill the center with rocks and earth." The switchbacks placed on Guinn Mountain were noted in an 1873 article from the *Rocky Mountain News*, "[The wagon road] then ascends to the top of the range by a zig-zag

route." The switchbacks as well as the cribbing of logs are still visible; these character-defining features were a part of the documentation for the 1997 National Register of Historic Places boundary increase.

The wagon road opened the area to early mining endeavors, further altering the ground once shaped by immense forces. Not only did prospect pits, placers, adits, mine shafts, and tailings appear, but also the infrastructure needed to sustain these efforts too, including cabins, wells, and areas for livestock. Records reveal little ore was extracted, yet the exquisite views were shared in letters written to newspapers—perhaps the only nuggets mined were comprised of rich adjectives and ebullient, expressive prose.

Near the turn of the 20th century, the pass would undergo its most substantial change in millennia; a route was surveyed and graded that wound its way up, across, and down Rollins Pass. The rocks first moved by plate tectonics, then by construction crews, found they had new companions: railroad ballast was laid along with ties and rail. David Moffat was building his Denver, Northwestern & Pacific Railway in an effort to connect Denver to the west over the spine of the continent: the rugged Rocky Mountains. The stones on this roadbed chattered while mallets—compound articulated locomotives—sped downhill and struggled uphill. Hit by blasts of steam and deafened by squealing brakes and shouting men, the rocks on Rollins Pass can fully attest to the impressive feat of running a standard-gauge railroad at high elevations.

Towns sprang up across the pass; Tolland, Ladora, Corona, Arrow, and other settlements backed this alpine railroading enterprise. Their stories would be studied along with their artifacts by generations to follow. The townsite of Arrow once accommodated over 2,500 people, more than the towns of Winter Park and Fraser combined, as of the 2020 decennial census.

In recent years, the historic integrity of Rollins Pass has come under new threat from unsympathetic developers longing to build atop soils rich with history that hold panoramic views. Of late, one attempt at a land exchange with the US Forest Service would have transformed the entrance of the western portion of Rollins Pass into an opening, quite literally, for a private development. Advocates rallied on behalf of public lands, and for now, the area remains in public hands. Embarrassingly, continued pro-development aspirations and the failure to see beyond real estate values only reinforces the area's inclusion as one of Colorado's Most Endangered Places.

In 1928, after a quarter century of operating over Rollins Pass and dealing with hazardous interruptions, the railroad found efficiency in an underground route through the mountains once built by the Laramide orogeny 70 to 40 million years ago. Rock was extracted from the heart of James Peak, crushed onsite at East Portal, and relaid as ballast inside the tunnel. The 6.2-mile-long Moffat Tunnel is not only a National Historic Civil Engineering Landmark, but also a realization of David Moffat's dream—plus was crucial to winning World War II as more than 30 defense trains hurried through the tunnel daily.

Meanwhile, on Rollins Pass, the backdrop underwent a transformative change as the tracks and buildings were dismantled and hauled away in the summer of 1936. The setting returned to a primitive landscape best characterized by 1905 railroad brochures, "Here is found the forest primeval in all its grandeur. Nature in her wildest aspect greets the traveler over The Moffat Road. . . . [T]he sightseer views Nature in her original beauty unmarred by the onward march of civilization and progress." What remains today has been true since the beginning of time: this area beckons the visitor because it is both wondrous and extraordinary. There is much to be shared from both past and present where rocks once tumbled across a frozen landscape that would serve as a great gate for many millennia: Rollins Pass.

CHAPTER 1

SACRED LANDS

THE PALEOINDIAN AND

NATIVE AMERICAN

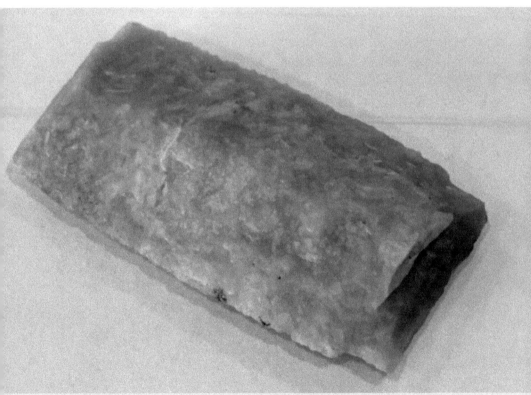

The Rollins Pass story is intricately complex, with many intersecting layers of history. In 2018, a Paleoindian artifact dating to 11,000 years ago was found on Rollins Pass and is now in Colorado State University's repository, held for the public trust. This 12.7-gram Scottsbluff projectile point midsection (RP-Wright-18-1-1) was fashioned more than 7,650 years before King Tutankhamun would rule in Egypt. The Ute and Arapaho tribes consider Rollins Pass to be a sacred area.

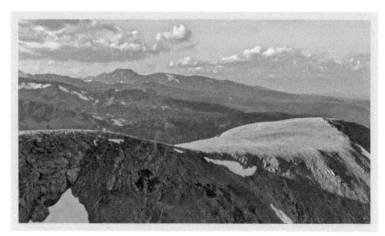

Professional archaeologist Jason LaBelle, PhD, explains because foothills resources were overexploited, prehistoric foragers "would have been forced to expand their diet breadth to include the resources of the alpine zone." They built communal hunting complexes atop Rollins Pass that required the cooperation of multiple hunters to effectively operate a hunting and butchery system of such a size and scale. Hunts were not only "economically viable" but "also served important social purposes." (Past image, courtesy of the Rose collection, Center for Mountain and Plains Archaeology.)

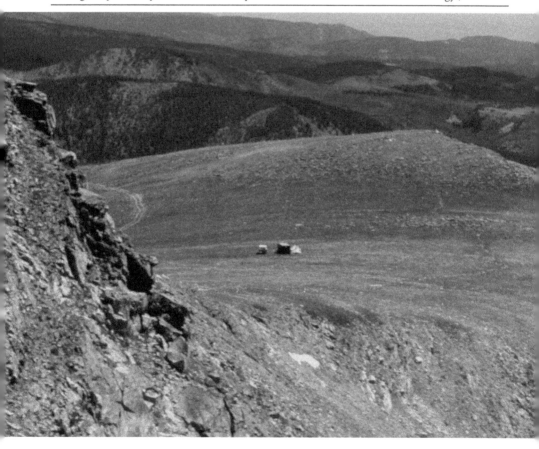

SACRED LANDS: THE PALEOINDIAN AND NATIVE AMERICAN

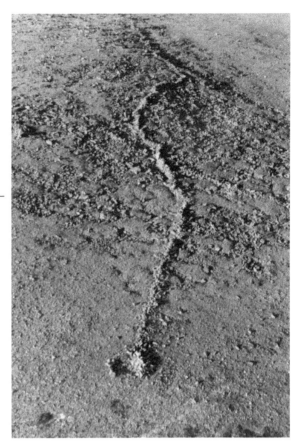

The sprawling game drive complexes atop the pass are internationally significant and the understanding of their use has changed substantially from 1869 when they were first mentioned in newspaper articles. Seventy-one percent of Colorado's known game drives are within the Colorado Front Range, an area that includes Rollins Pass. Above all, "Rollins Pass has been identified as a sacred area for the Ute and Arapaho," per US Forest Service documents. (Past image, courtesy of the John Slay Archive, Center for Mountain and Plains Archaeology.)

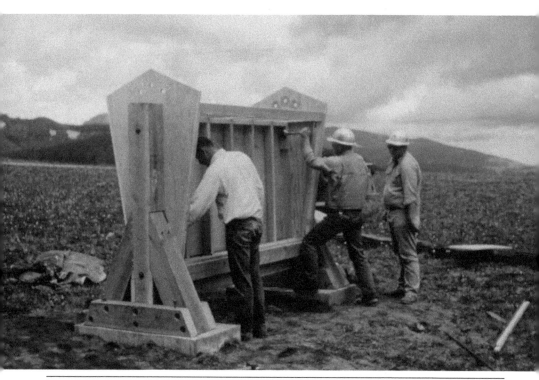

Workers install framing for the now well-recognized sign at the summit of Rollins Pass. Original and subsequent iterations of the marker referenced the railroad and toll wagon routes, and it was not until 2018 when replacement text mentioned Native American use of the pass thousands of years ago. Much of what is now known about the prehistoric use of the pass is through research conducted by Colorado State University archaeology field school students, led by Jason LaBelle, PhD. (Past image, courtesy of USFS.)

SACRED LANDS: THE PALEOINDIAN AND NATIVE AMERICAN

A GREAT GATE

TRAVERSING ROLLINS PASS

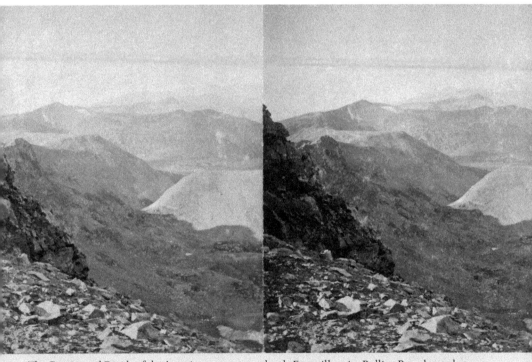

The Continental Divide of the Americas—a great mountainous barrier—stretches from Alaska to Panama. In Colorado, this hydrological divide varies in elevation from 10,000–14,000 feet above sea level. For millennia, Rollins Pass, located at one of the narrower widths of the Continental Divide, has been an attractive crossing, or great gate, with a moderate 11,677-foot elevation.

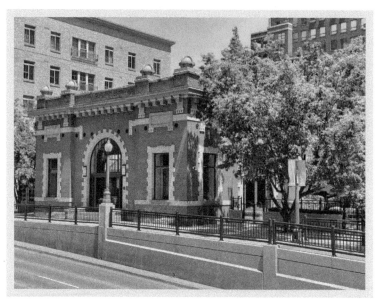

Denver architect Edwin Moorman designed the square Moffat Station building that would serve as the Denver terminus of the Denver, Northwestern & Pacific Railway. An earlier depot, built June 1904, was two blocks away—this structure eventually was moved to Tolland, Colorado. In January 1906, construction of the Moffat Station began. The completed building represents Georgian Revival architecture and is now the focal point of a retirement community complex. (Past image, courtesy of the Library of Congress, Prints & Photographs Division, HABS CO-83-1.)

A GREAT GATE: TRAVERSING ROLLINS PASS

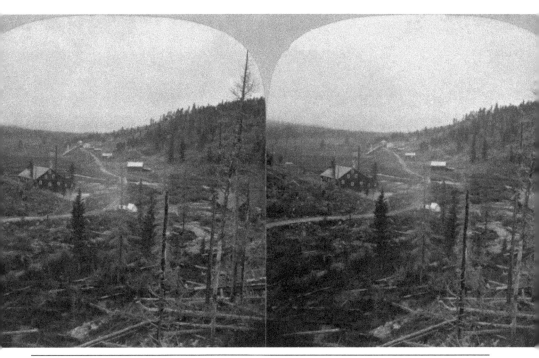

This stereocard shows a very early view of Gold Dirt, later Rollinsville. John Quincy Adams Rollins set up a quartz mill here in the winter of 1860–1861. This soon made him wealthy, and he used his fortune as a road builder within Colorado. His first road, a toll wagon road, stretched for 40 miles from Rollinsville to Hot Sulphur Springs over what was then known as Boulder Pass. The undertaking cost Rollins $20,000. (Past image, courtesy of the Denver Public Library, [Call X-13213].)

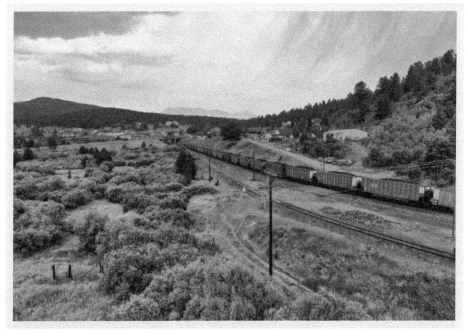

In 1873, John Rollins began building his toll wagon road from Rollinsville toward the mountainous horizon. In 1866, Rollins played a 32-hour billiards match against Charles A. Cook in lower downtown Denver. The tournament at Brandlinger's cigar store at the intersection of Blake and F Streets was so popular, the event was standing room only, and many closed their businesses to watch. The luck of each man continuously changed. Rollins forfeited the match, losing $1,000; however, he took home $11,000.

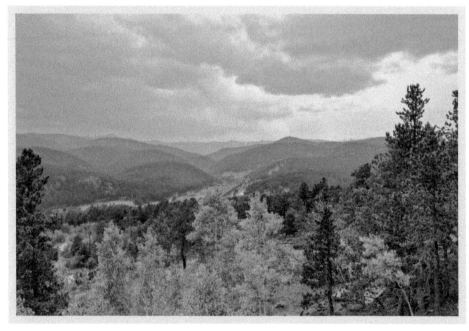

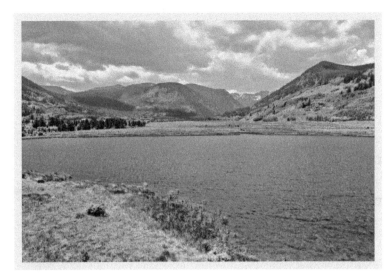

Dreamy and peaceful Tolland holds a heart-throbbing World War II story, shared by historian Leda Reed: "The excitement of a troop train passing through threw [the ladies] into a frenzy. . . . [The troops] would be hanging out of the windows waving and throwing kisses. Once in a while the train had to lay over at Tolland. When [the troops] saw us, out the windows they came. We would hand them wild flowers and occasionally our address."

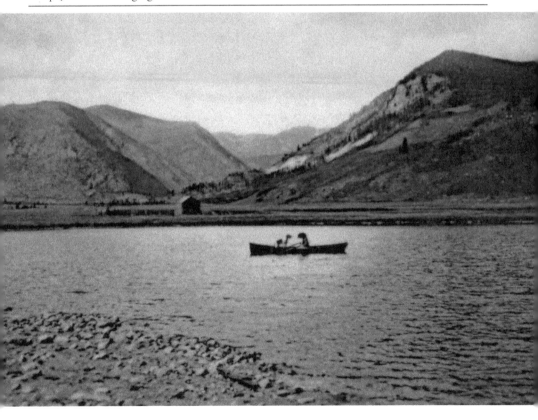

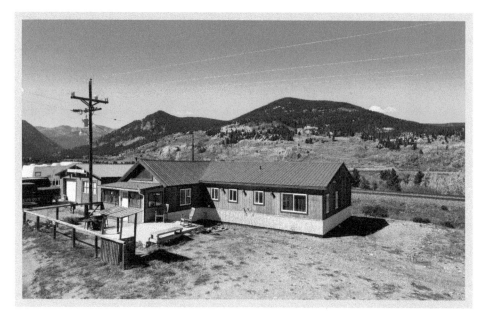

This one-story, gable-front frame commercial structure was built around 1904 and originally had a false front, common for such a setting in the early 20th century. The building was once neighbor to the Tolland dance pavilion, now demolished. In the 1950s, the building served as a popular spot for visitors to purchase snacks and cold drinks. Today, it is a private residence for the caretaker family who provides around-the-clock security for Tolland Ranch. (Past image, courtesy of GCHA.)

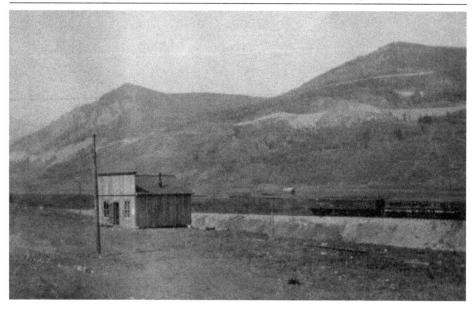

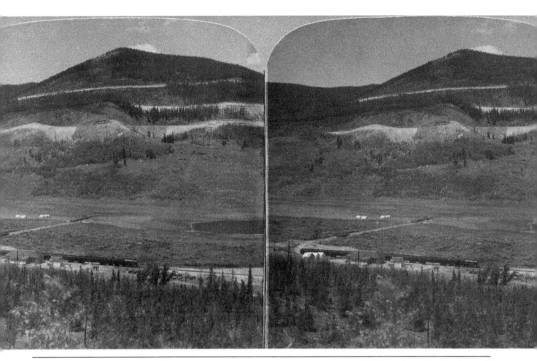

In 1893, Charles Hansen Toll, a mining attorney and former attorney general of Colorado, purchased Mammoth from John Osgood and Paul Blount for $1,000. It was Toll's intent to dam the South Boulder Creek to have a reservoir for his ranching interests near Broomfield, Colorado. Charles Toll died suddenly at age 51, and his wife, Katharine Wolcott Toll, chose instead to develop Tolland (named after Tolland, England, her ancestral home) by selling mountain cabins for seasonal use.

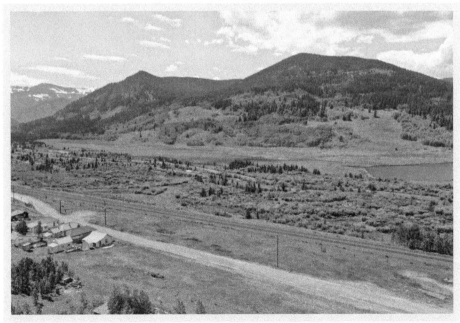

This 2021 photograph of H. Wolcott Toll, PhD, was taken at the site of the Toll Inn, which unfortunately burned on Saturday, December 17, 1910, from an out-of-control chimney fire and was never rebuilt. Dr. Toll, nicknamed "Wolky," is a professional archaeologist and is the great-grandson of Katharine Wolcott Toll, pictured right. The Toll family established a lasting and durable legacy to forever protect Tolland and the lower eastern portion of Rollins Pass with a conservation easement. Per a 2015 press release, this is "one of the largest intact private holdings along the Front Range," and the conservation easement protects "critical drinking water sources for Boulder and Denver, improves forest management and safety, and sustains and enhances recreational opportunities." (Past image, courtesy of the H. Wolcott Toll collection.)

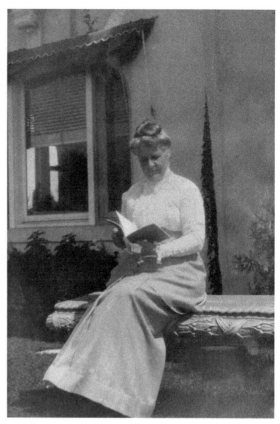

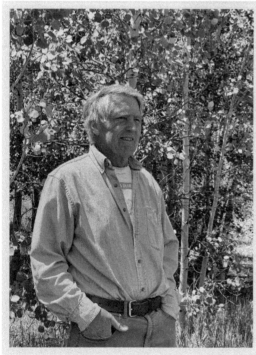

The rugged Rocky Mountains draw ever-nearer as the traveler receives the first close-up of the towering granite and snow-covered wall separating the Atlantic and Pacific watersheds. This historic photograph is provided courtesy of the Tyler family; their great-grandfather, Charles Crocker, worked on the Moffat Road over Rollins Pass. His legacy shines brightly throughout this book with six original photographs from his awe-inspiring collection. His images are on pages 43, 49, 56, 77, and 83. (Past image, photograph by Charles Crocker; courtesy of the Tyler family.)

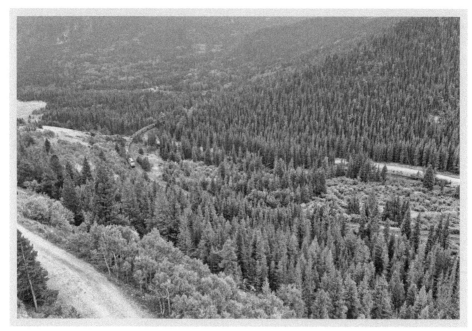

This is a look taken above the initial rung of Giant's Ladder as it rises over the valley floor in Tolland. For nearly 120 years, trains continue to sound and echo throughout this basin. Each year, Tolland continually surprises the visitor with a decadent visual treat: an endless carpet of vibrant spring and summer wildflowers, followed shortly thereafter by a majestically ostentatious golden autumn replete with fluttering aspen leaves. (Past image, courtesy of Tristan Anderle.)

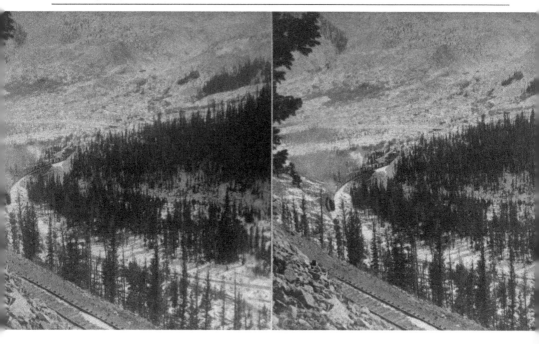

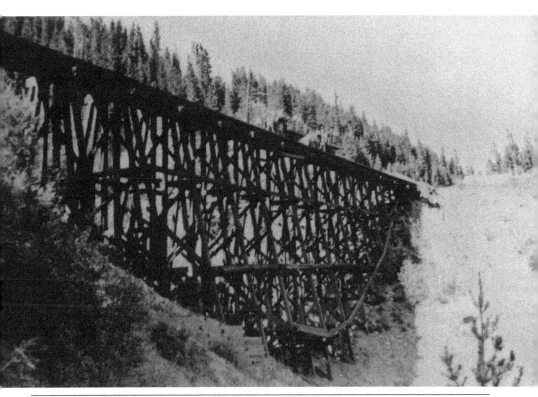

A now dismantled trestle once spanned the 288-foot gap on the first step of Giant's Ladder. These wooden structures were constructed along the pass without the benefit of computers, lasers, or global positioning systems (GPS). Ironically, the modern photograph was taken mere feet above the very loose and steep soils with an aerial Hasselblad L1D-20c camera, while the flight was precision-stabilized by nearly two dozen orbiting GPS satellites, holding position to six decimal places for both latitude and longitude. (Past image, courtesy of the Carnegie Branch Library for Local History.)

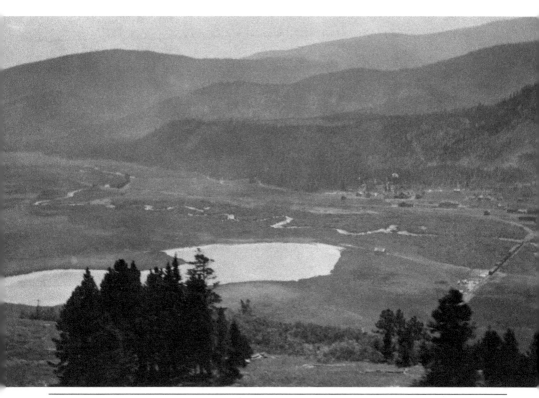

A two-stall roundhouse—not a circular structure—is the largest building to the extreme right, mid-ground of the image above. The roundhouse was "completely destroyed by fire" on the night of Tuesday, April 12, 1910, declared the *Steamboat Pilot*. In addition to the structure's loss, the railroad company saw Mallet No. 200 and a rotary snowplow "damaged to the extent of several thousand dollars" penned the *Yampa Leader*. Construction of a replacement building started in June of the same year.

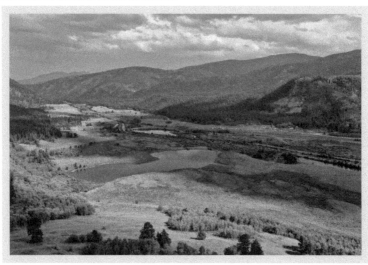

A GREAT GATE: TRAVERSING ROLLINS PASS

Ladora, not to be conflated with neighboring Eldora, was a community nestled amongst pine and quaking aspen in a clearing where the first rung of Giant's Ladder rounded a knoll to begin the second rung. This idyllic setting, now silent, was the site of a sawmill and a railroad spur—at which point lumber from the mill was loaded onto railroad cars. The J.R. Quigley Lumber Co. first operated this mill in 1904. (Past image, courtesy of Robert Zarlengo.)

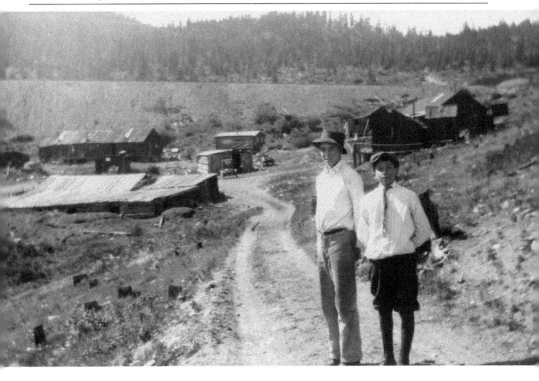

In 1911, two Italian immigrant brothers, Charles and George Zarlengo, arrived in Colorado; Charles settled in Ladora and reopened the sawmill, and George went to Denver to manage their flourishing contracting business. Soon after, Charles married Linda Moauro and George wedded Elizabeth Fabrizio—both families welcomed nine children. In the summers, 18 children filled the valley at Ladora with carefree laughter. (Past image, courtesy of GCHA.)

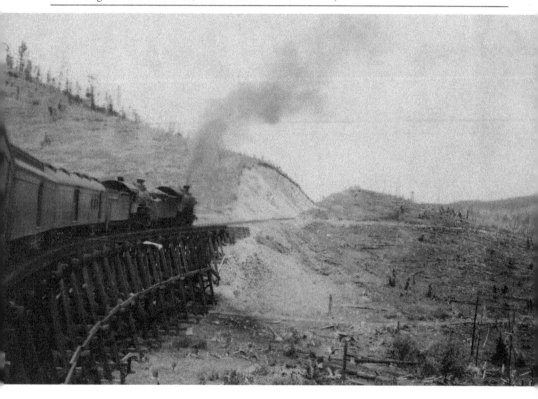

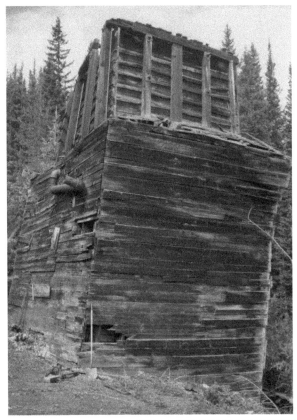

Ladora included 2,000 feet of siding, a 68-foot spur, one 23-panel and one 16-panel trestle, a square water tank, and the first tunnel on Rollins Pass at 550 feet long, Tunnel No. 31. The square water tank, recounted by engineer Dan Crane, served as an emergency water reservoir. The structure, insulated with straw, collapsed during the winter of 1989–1990, yet the seven-inch iron pipe is still visible atop the ruins. Ladora, while once a bustling sawmill astride a busy mountain railroad, is closed to the public. (Past image, courtesy of Rich O'Leary.)

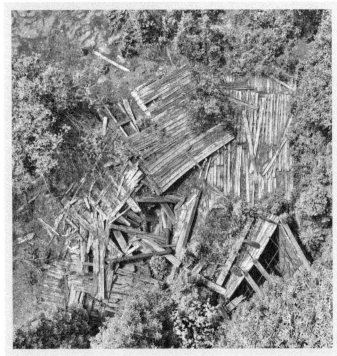

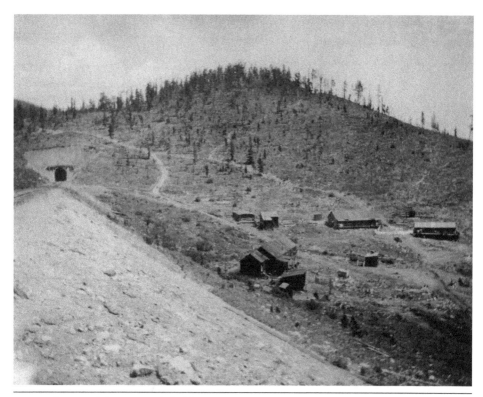

Twenty-five woodchoppers and skidders lived up-grade from Ladora, pictured above. They worked for the Zarlengo family to produce timber for mines in the area. Historic triplicate invoices show "out of Tolland, Colorado," a customer "bought of Chas. Zarlengo all sizes of mine props and mine ties" that were shipped by railcar(s). Each bill of sale has columns for pieces, size, and length, along with descriptions and prices. (Past image, courtesy of Robert Zarlengo.)

A GREAT GATE: TRAVERSING ROLLINS PASS

Tolland author and historian Leda Reed explains for each summer at Ladora, "Washing was done over the scrub board and strung up to dry. A huge outdoor oven modeled from the ovens in the [Italian] 'old country' produced twice weekly eight gigantic loaves of bread." Natural mountain springs, which can still be found and used today near "Old Camp," provided icy water for hot July and August days experienced at Ladora. (Past image, courtesy of Robert Zarlengo.)

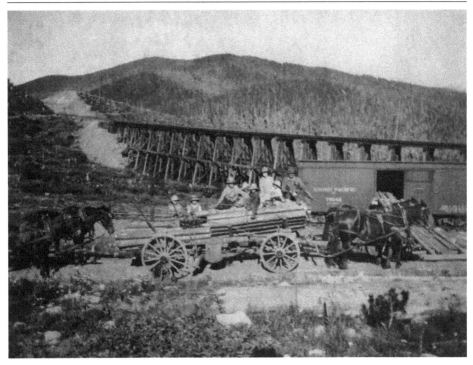

The first human passenger injury on Rollins Pass occurred on April 10, 1917, at Ranch Creek Wye. A few years later, in early June 1919, a railcar containing 13 horses turned over on its side close to Antelope and the Spruce Wye, pictured below. This accident injured valuable Percherons being transported to the Gossard Exhibition, including a mare, Jeune, who earned blue ribbons in both the United States and France as she had "never been beaten in the show ring," reported the *Moffat County Courier*. (Past image, courtesy of GCHA.)

Blasting through rock cuts and creating tunnels was made far easier through the use of black powder. Archaeology teams have found empty and deteriorating Laflin & Rand powder canisters on Rollins Pass. Notably, Laflin & Rand protected its proprietary formula using Vigenère ciphers, an encryption method developed in 1898 that utilizes interwoven Caesar ciphers dating to more than 2,000 years ago to scramble words. The encoded formula was unbreakable without the key.

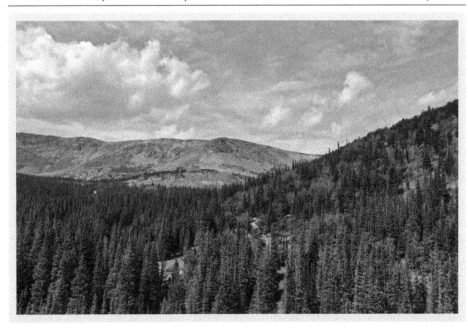

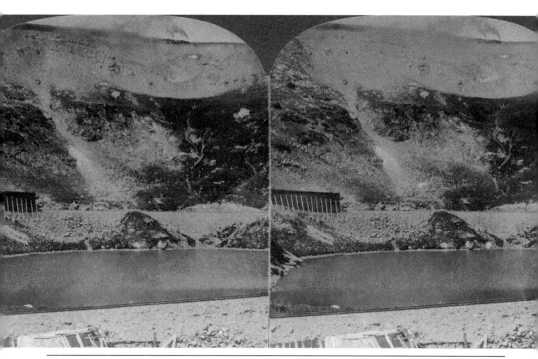

John Quincy Adams Rollins revealed the soon-to-be world-famous Yankee Doodle Lake in his "Picturesque Route to Middle Park" article in the September 18, 1873, *Rocky Mountain News*: "The town of Yankee Doodle is situated at the head of the north fork of the South Boulder, which has its source in Lake Jennie [*sic*]. . . . Around this picturesque little lake and the town is a beautiful park of grass embracing some three hundred acres, interspersed with beautiful little groves."

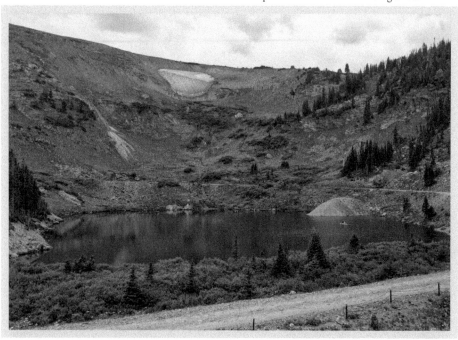

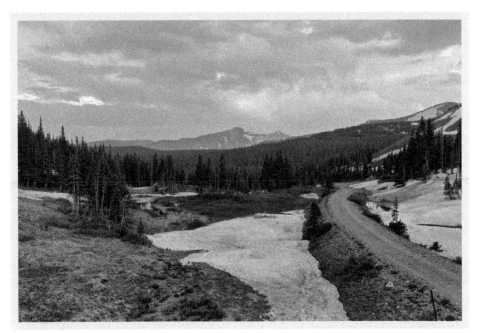

In 1882, the first official patents for mining near Yankee Doodle Lake were filed by the Newport Mining and Manufacturing Company. The 1893 repeal of the Sherman Silver Purchase Act of 1890 led to a slow demise of mining operations in the area. In 1903, the mines changed ownership, and about one year later, the railroad changed the landscape at Yankee Doodle Lake forever. (Past image, courtesy of the Denver Public Library, [Call L-591].)

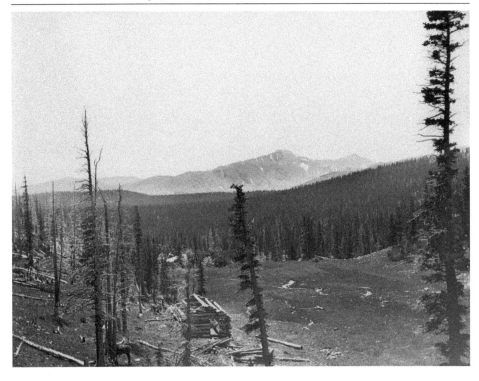

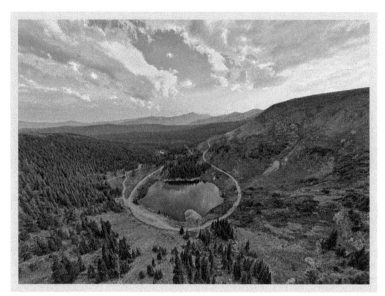

Perhaps no area on Rollins Pass is better known or more beloved than Yankee Doodle Lake. Its alluring location serves as a landscape-sized time capsule and, as seen in the past image, a unique trunnion for the Moffat Road. In 2021, the authors hiked here with Holly Norton, PhD, state archaeologist and deputy state historic preservation officer, to document ancient finds from thousands of years ago as well as a lost chapter of the Rollins Pass story dating to the 1860s. (Past image, courtesy of Tristan Anderle.)

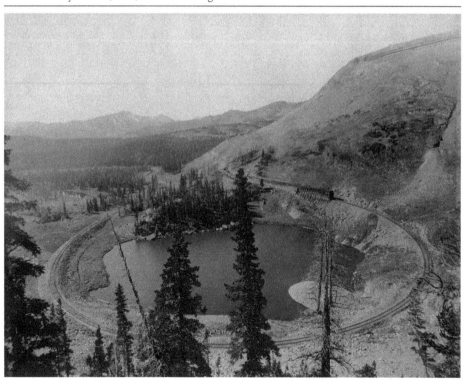

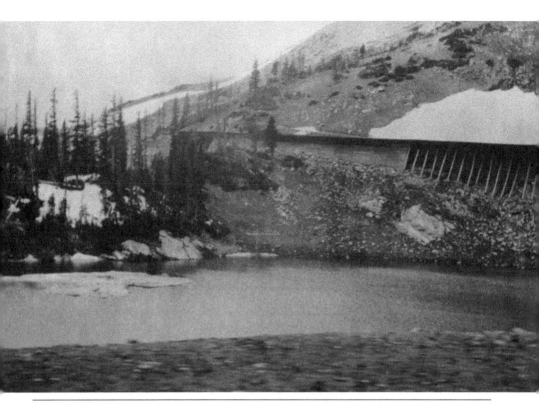

Yankee Doodle Lake both inspires and stores apocryphal stories about submerged wrecks contained within, including a 19th-century wagon, a 20th-century locomotive, and even an airplane. All variations of the anecdotes follow an identical trajectory, "if the light is just right." However, all that can be seen in the lake is the reflection of a visitor yearning for a deeper connection to the area's vast history. (Past image, photograph by George Engle; courtesy of Tom Jacobs.)

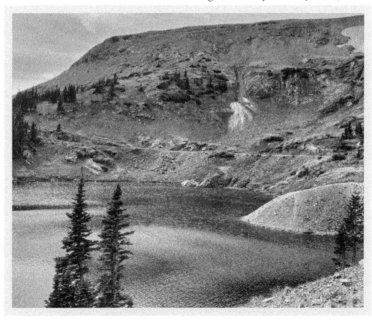

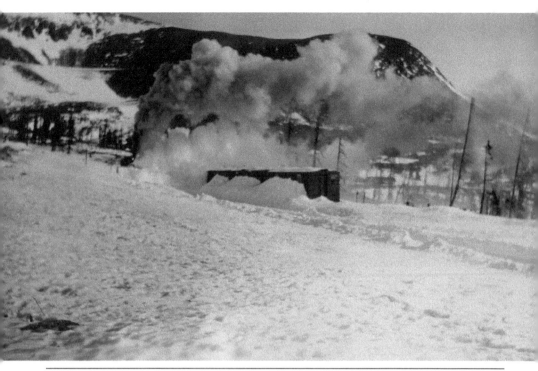

Engineers who drove trains up and down Rollins Pass stated the top speed for moving downhill on a four-percent grade was 15 miles per hour. Any faster, and the engineer risks stressing the brakes to bleed off excess speed and might not be able to hold the train on a curve. Historical records indicate there were more than three dozen wrecks, derailments, or mishaps in the quarter century trains operated over the Continental Divide. The Hill Route had more than 10,800 degrees of curvature.

A GREAT GATE: TRAVERSING ROLLINS PASS

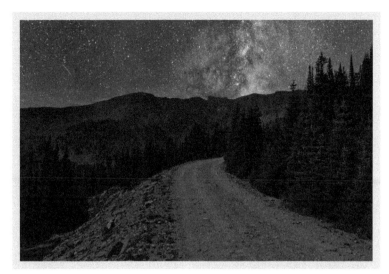

Famed photographer Louis Charles McClure captured iconic scenes used by the railroad for marketing purposes. While McClure was skilled behind the camera, he also modified some of his work 85 years before Photoshop. For instance, the historic image below is of a moonlit scene, yet the stars have been added by hand. Other photographs altered by McClure are not supported by archaeological evidence; McClure's composites sometimes are impossible to recreate in the configuration his photography suggests. (Past image, courtesy of the Denver Public Library, [Call MCC-135].)

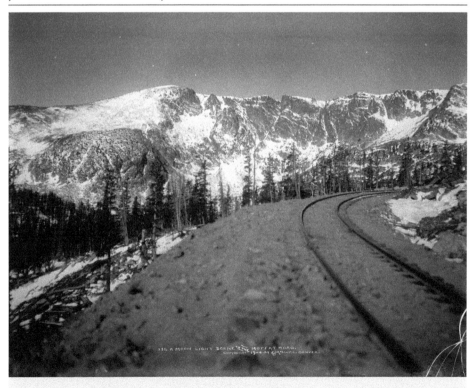

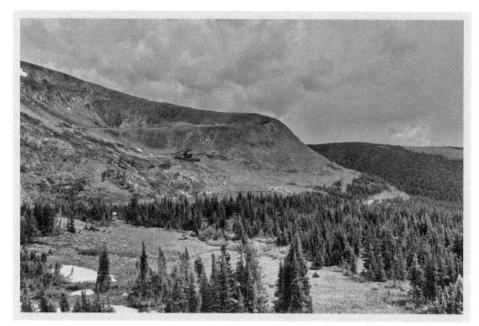

Newspapers were critical of Rollins Pass and stressed the need for a tunnel through the Continental Divide. The *Routt County Republican* wrote on January 25, 1918, "We surely need a tunnel, for it is doubtful whether providence ever intended a railroad to be built over Corona [P]ass" and the *Meeker Herald* wrote one day later, "The Moffat Road will remain a winter failure till the Rollins Pass tunnel [Moffat Tunnel] is built." (Past image, courtesy of GCHA.)

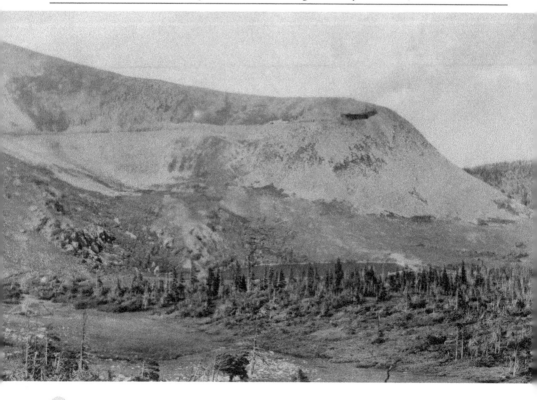

A GREAT GATE: TRAVERSING ROLLINS PASS

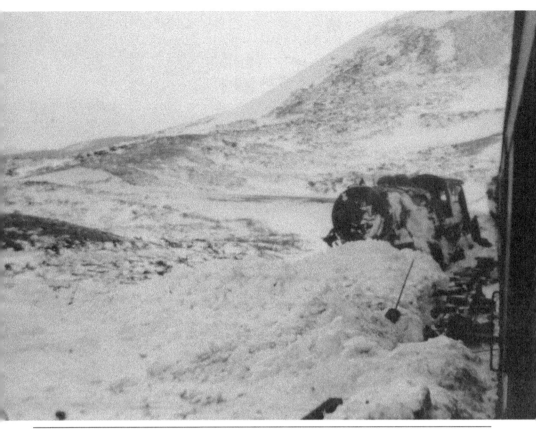

Wrecks were an all too familiar scene on the Moffat Road's Hill Route. The *Fairplay Flume* on January 29, 1915, got straight to the point about stories of this area and a recent death on Rollins Pass: "Mathias Roberts, a locomotive engineer of Tabernash, was crushed to death when a rotary snowplow broke within three miles of Corona Pass, the highest railroad point in the world, and tore down the eastern slope . . . at terrible speed. The plow left the rails on a curve and dashed down a thirty-foot hill." (Past image, provided courtesy of Tread of Pioneers Museum, Steamboat Springs, Colorado.)

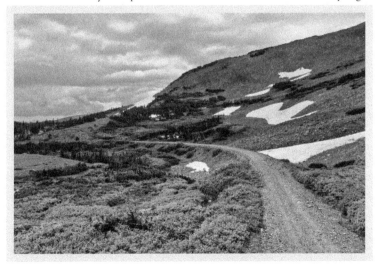

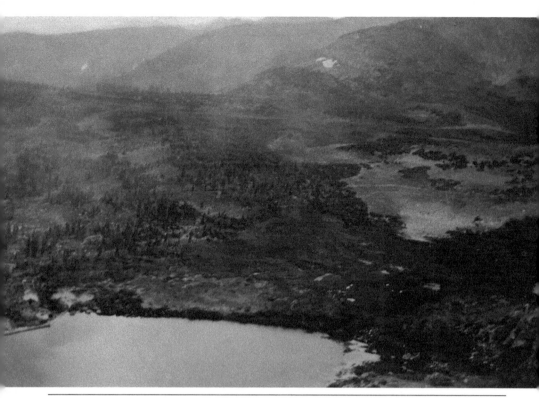

Various routes on and over Rollins Pass have been closed since 1980; and from 1990 onward, Rollins Pass has been completely closed as a motorized thoroughfare across the Continental Divide. Nevertheless, other means remain available for transiting the pass: cross-country skiing, snowshoeing, fat biking, mountain biking, and overflying aircraft. There are also two timeless methods available, representing perhaps the most historic ways to view the sweeping vistas that define Rollins Pass: horseback riding and hiking.

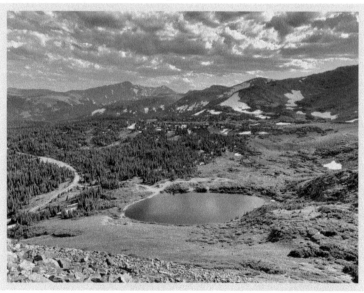

A Great Gate: Traversing Rollins Pass

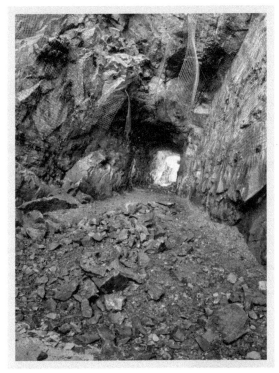

This phantasmagorical image of Needle's Eye Tunnel was meticulously restored from the original, revealing much about the scene. On the left side of the image below, a man stands in front of a ladder. In the background, near the entrance of the southwest portal, is a surveyor's tripod; the nearby case likely contains a theodolite. On the tracks, a tool rests on a tie mid-ground, while two human silhouettes stand in the background. On the right side, drill steel bits and buckets rest on the tunnel floor, while six workers stand—some with their tools. The conspicuous absence of ballast in between the wooden ties suggests the photograph was taken shortly after the track was laid through the tunnel. (Past image, photograph by Charles Crocker; courtesy of the Tyler family.)

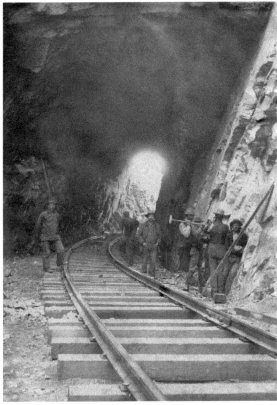

The Needle's Eye Tunnel has had a bloody history. As reported in the *Steamboat Pilot*, a road contractor "once saw 60 Swedes carried out in baskets, killed when a charge of powder exploded prematurely in boring this tunnel." Almost 13 unlucky years later, a freight derailment occurred inside Needle's Eye Tunnel as reported by the *Oak Creek Times*. Unfortunately, the past is prologue; tunnel restoration errors led to a partial collapse, resulting in a below-knee amputation of assistant fire chief Tom Abbott in 1990. Abbott expressed, "I was lucky the firefighters [who were with me] had what it takes. They and two civilians stood in there while the ceiling was still falling and dug me out . . . of the pile of 'coffee-table-sized rocks.' " Later that same year, a post-accident engineering report cited "faulty work: design specifications were not consistently followed . . . rock bolts were incorrectly spaced . . . gravity along with seasonal temperature variations were . . . factors in the accident." (Past image, courtesy of John Rodden.)

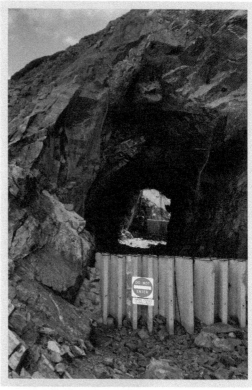

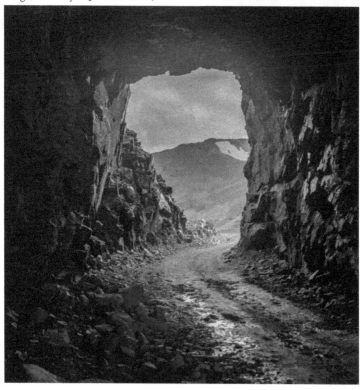

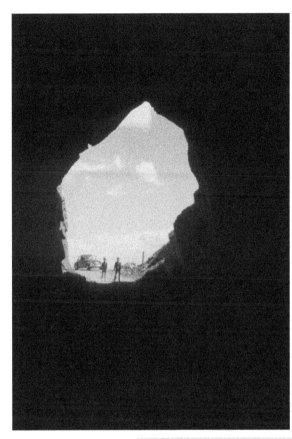

Before the 1990 accident (see opposite page), significant rockfalls had occurred at the northeast portal of Needle's Eye Tunnel by 1949 as well as in 1979. Rehabilitating the tunnel triggered the Section 106 process, as any actions or proposed alterations must be federally reviewed. In the 1980s, it was documented this tunnel "is in an advanced state of deterioration," has a "very irregular geometry," and "much of the surface rock structure, around the portals, was damaged and weakened during construction by the excessive use of explosives in blasting." At 11,350 feet above sea level, extreme freezing and thawing in rock fractures occurs, further accelerating the weathering process, and "the centerline of the tunnel is essentially parallel to the joint sets in the rock, which tends to create a weakened surface condition." Additional fundamentals about the Section 106 process are listed on page 53. (Past image, courtesy of the Hans and Uta Pott family.)

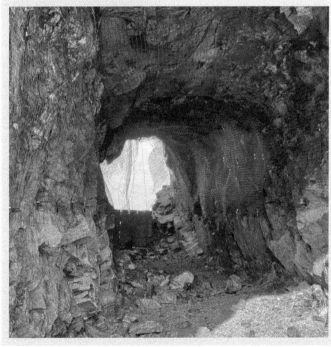

The southern half of Guinn Mountain had been ravaged by fire a few years before the above photograph from John Trezise was taken. In mid-September 1901, "the Great Eldora Forest Fire of 1901" swept through this area, destroying much of the mature forest as it burned nearly 40 square miles of woodland terrain. A miner, McMurtie, tried to rescue his personal effects from his burning cabin but soon after succumbed to his injuries.

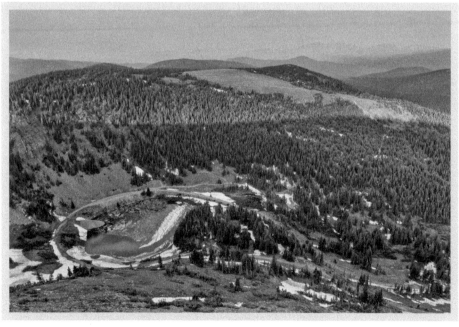

The portion of the historic wagon road that runs atop Guinn Mountain has a year-round closure "to travel by wheel-to-ground motorized vehicles" per 36 CFR 261.54(a), Forest Closure Order 10-00-03. This route has been closed since 1980, as portions of the road are within the wilderness, where motorized use is prohibited. The closure was reinforced in 2006 and helps protect the wood cribbing that is listed as character-defining for the National Register of Historic Places entry as well as the historic switchbacks placed in the 1870s by John Quincy Adams Rollins. (Past image, courtesy of Jason LaBelle, PhD.)

Layers of history intersect near this junction on Rollins Pass. Off-roading groups continue to push for an opening of the Boulder Wagon Road, however, as mentioned in 1980s Section 106 documentation, "Prehistoric game drive sites ([5BL145], 5BL146, 5BL147, and 5BL148) are located within the area of potential effects of [such an] undertaking, and 5BL147 and 5BL148 are actually crossed by the existing Boulder Wagon Road." All ancient properties are eligible for the National Register of Historic Places under Criterion D "for their potential to yield information about the use of high-altitude environments by prehistoric peoples."

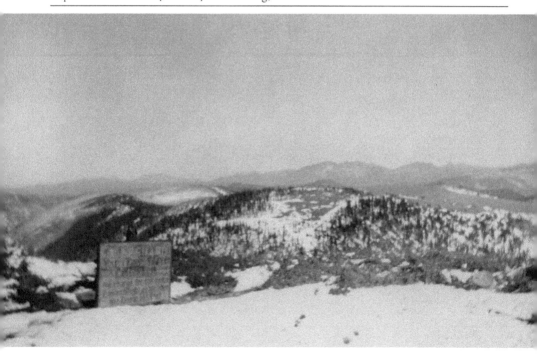

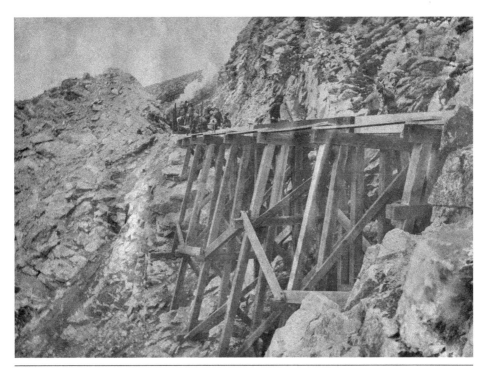

This exceedingly remarkable construction photograph transports the reader to the day the Devil's Slide Trestle was being crafted into the mountainside above the South Fork of Middle Boulder Creek. Fashioning the structure involved steely-eyed carpenters, with likely white-knuckles; the 17 men pictured had unobstructed views to the bottom of the canyon where more than three Statues of Liberty could be stacked, and still, the Lady Liberty trio would not reach the decking of the trestle. (Past image, photograph by Charles Crocker; courtesy of the Tyler family.)

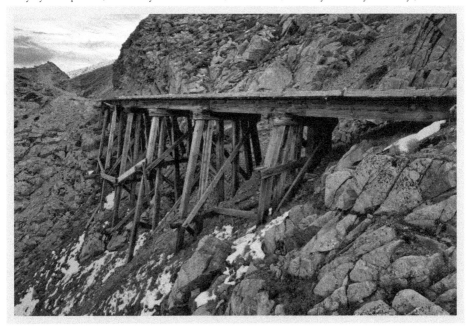

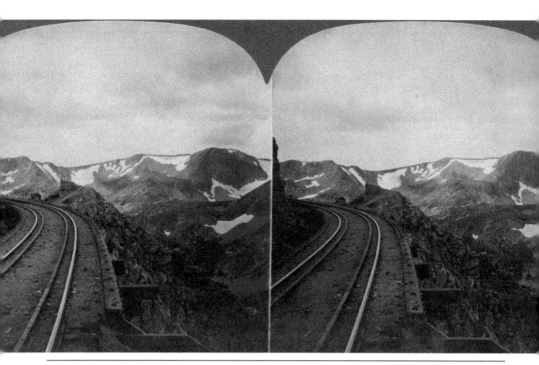

Located between 11,475 and 11,500 feet above sea level are the "twin trestles." While undeniably more fraternal than identical, the shorter twin is commonly referred to as the Devil's Slide Trestle—it has an elegant arc, a noticeable banking turn, and is an eight-panel, 128-foot-long masterpiece. Only 0.11 miles further uphill, a 240-foot, 15-panel trestle known as Phantom Bridge crosses the other chasm and is largely straight with a subtle curve at the uphill and westerly end.

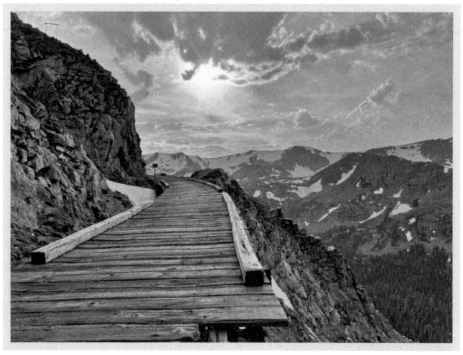

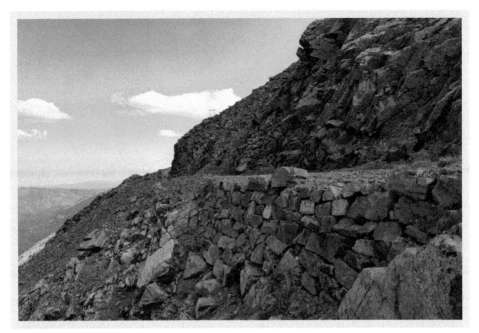

Visible in the foreground is a drystack retaining wall, placed by the railroad to control erosion in narrow zones. The mortarless courses of rock are able to shift somewhat as freezing and thawing occurs, yet the facade remains load-bearing. Drystack retaining walls seem to be more prominent on the east side of Rollins Pass, with a lengthy wall located upgrade and downslope from Needle's Eye Tunnel. (Past image, courtesy of the Denver Public Library, [Call MCC-455].)

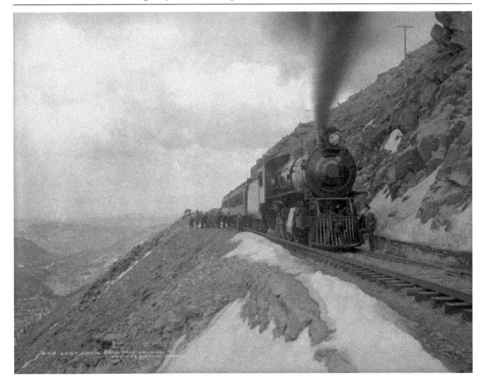

The October 8, 1953, *Steamboat Pilot* chronicled tales of this area: "Several years ago I was riding horseback over one of the old wooden trestles and the horse peered down thru [*sic*] an opening where a tie should have been. He thereupon decided it was no place for a horse and reared back, and for a minute, I thought I would be riding a bronco thru [*sic*] the air to those rocky canyon slopes below." (Past image, provided courtesy of Tread of Pioneers Museum, Steamboat Springs, Colorado.)

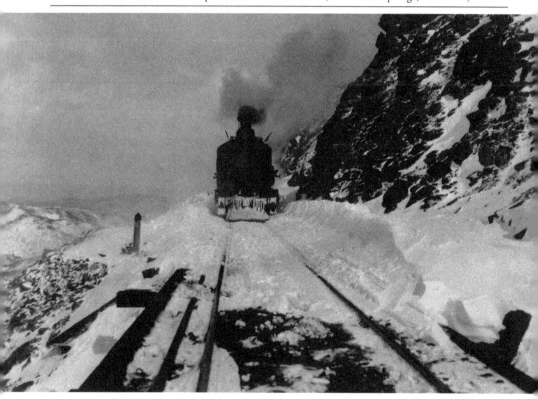

A GREAT GATE: TRAVERSING ROLLINS PASS

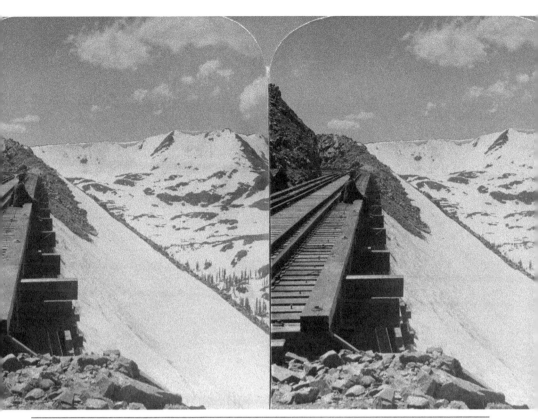

The 1980s Section 106 review process detailed the many management concerns of Rollins Pass, including the National Historic Preservation Act, which calls for the preservation of known historic sites, protecting the public—officials are prevented from allowing the public to utilize facilities known to be hazardous, meeting visual management objectives of making no alterations to the landscape that will not preserve or enhance the existing visual quality, maintenance costs, technical possibility of alternatives, and economic feasibility of alternatives. (Past image, courtesy of Moffat Road Railroad Museum.)

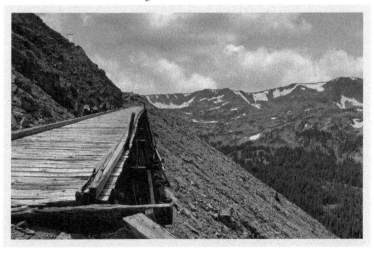

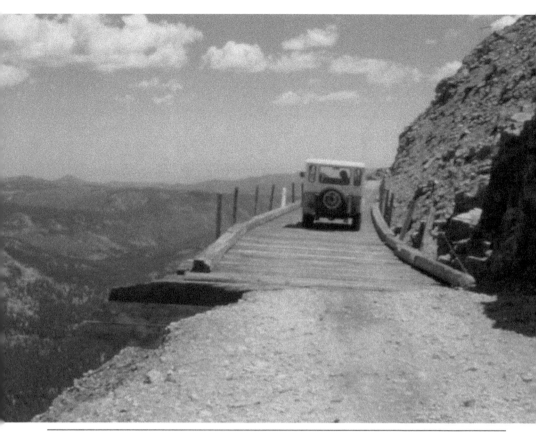

Located roughly halfway between Tunnel No. 32 (Needle's Eye Tunnel) and the summit of Rollins Pass, one of two magnificent wooden trestles clings to a steep outcropping that serviced rail traffic from 1904 to 1928. From 1956 to 1980, these trestles were deemed strong enough to carry passenger vehicles. Since 1980, and per US Forest Service Motor Vehicle Use Maps (MVUMs), the trestles have been closed to all forms of traffic except horseback riders, bicyclists, and hikers. (Past image, courtesy of Gregory Dietz.)

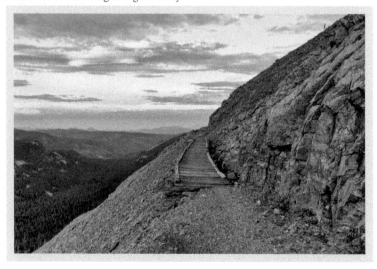

Rollins Pass had more infrastructure a century ago, solely because of the existence of the railroad over the Continental Divide. Today's visitors encounter large snowdrifts and a dearth of snowplows, no fueling stations, and they might struggle to find cellular reception, particularly on the east side of the pass. Yet long ago, rotary snowplows were a regular occurrence, as were emergency fuel depots, while telegraph poles crisscrossed the landscape. (Past image, provided courtesy of Tread of Pioneers Museum, Steamboat Springs, Colorado.)

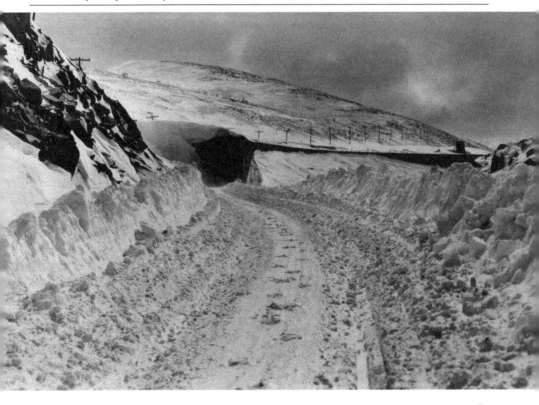

The past photograph was taken Monday, June 6, 1904, while workers continued their push over the pass. Generations later, the Indian Peaks Wilderness boundary—a line with no width—can be found at the edge of the railroad grade. The line connects the turning points spelled out in the actual boundary survey, "Thence west along north shoulder of Rollins Pass Road (No. 149) for 1.27 miles to a point at intersection of [an] 11,640 foot contour." (Past image, photograph by Charles Crocker; courtesy of the Tyler family.)

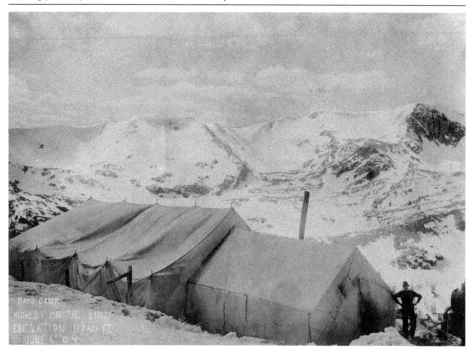

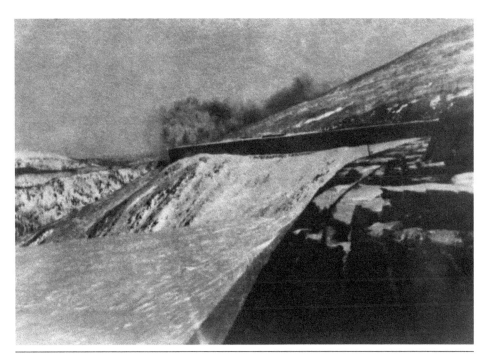

A quarrel over a newspaper resulted in a fatal shooting at the town of Corona—its snowsheds pictured above—atop Rollins Pass in July 1913. As relayed in the *Herald Democrat*, a blacksmith of the Denver & Salt Lake Railroad picked up a newspaper from the telegraph operator's desk. The telegraph operator, J.E. Bascable, shot Lawrence Larson in the abdomen "without provocation," wrote the *Moffat County Courier*. Bascable was "hurried to [the] Hot Sulphur Springs jail" and would later be "adjudged insane." (Past image, courtesy of GCHA.)

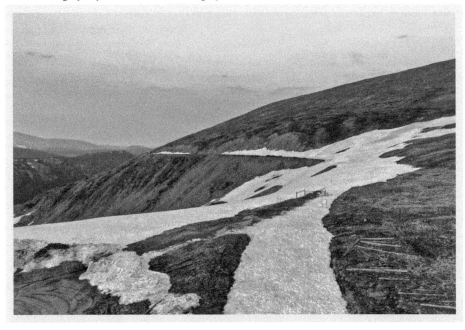

In summer, the top of the pass abandons its thick blanket of snow to reveal a limited number of parking spots that are quickly filled each morning. Experiences shared by Charles Plantz from 1974, before Colorado's population boom, are unrealizable today: "I don't recall meeting, or seeing, any other traffic, either up the east side or down the west." The pass is sandwiched between the Indian Peaks Wilderness, created in 1978, and the James Peak Wilderness, established in 2002.

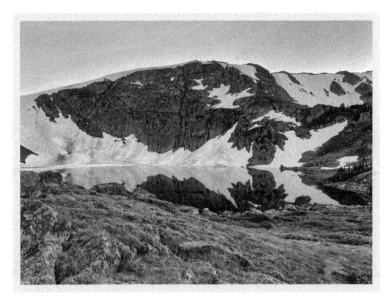

The sheer rock cliffs rising out of the icy waters at King Lake (also known as Emerald Lake and sometimes Echo Lake) paints a timeless scene. Once seen as a waypoint through the crest of the Continental Divide for a failed narrow-gauge route that altered the landscape slightly with a tunneling attempt, the area now represents a landscape ensconced in the serene wilderness. The Denver, Utah & Pacific Railroad was ultimately superseded by the Moffat Road over Rollins Pass. (Past image, courtesy of GCHA.)

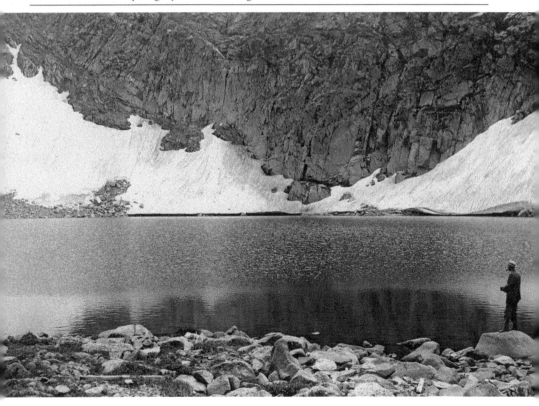

The August 25, 1866, *Rocky Mountain News* contained baroque metaphors from early travelers: "A Faber No. 2 [pencil] is not capable of describing the beauties revealed to us before, behind, right and left, and our hand shall not attempt to make it. Fatigue and hunger is forgotten, and the soul is fed with beauty. Here Flora holds high court, clothed in matchless garments. The snow King fades away, and rushes madly roaring down the valleys before her smiling presence."

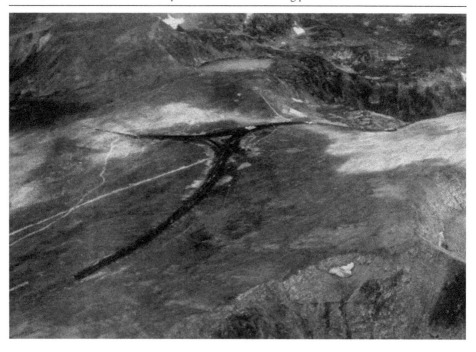

A GREAT GATE: TRAVERSING ROLLINS PASS

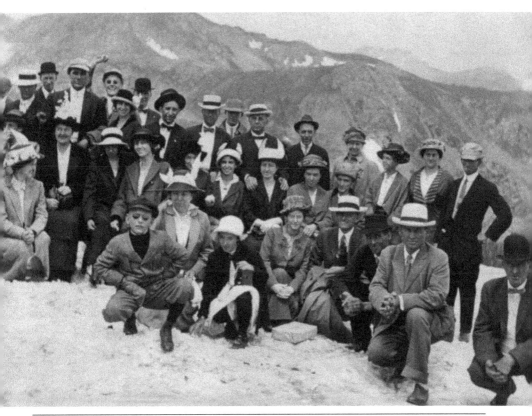

A tourist visiting Corona in the summertime wrote for the August 3, 1911, *Greeley Tribune*, "As all those who have taken this trip know, it is one of the most scenic mountain trips in Colorado, where mountain scenery is a chief product. . . . Snow banks and wild flowers, as the literature tells you, is right." Concluding, "The next time [the author] goes to Corona he will borrow an overcoat to take along, for there ain't no summer up there."

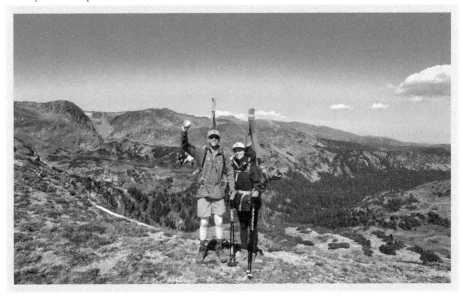

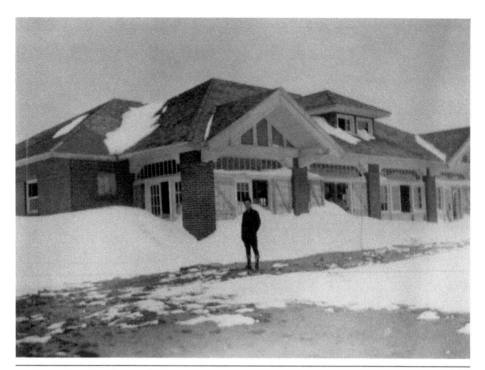

The first Colorado architect to be licensed through examination, Leo Andrew Desjardins designed the $15,000 red-bricked and green-roofed dining hall at the top of Rollins Pass. The building was operated by the Barkalow Brothers company—this entity operated the eating houses at both Arrow and Tolland. A single line in a US Forest Service report dated April 3, 1937, says, "The Corona Club House was dismantled, the bricks salvaged and hauled down to the Idlewild Ranger Station by ERA crews."

A GREAT GATE: TRAVERSING ROLLINS PASS

It was March 3, 1917, and at the town of Corona, inside the baggage car of a Denver-bound train, an 8.5-pound boy was born named David Moffat Haynes, in honor of railroad tycoon David Moffat. The only other woman on the train assisted, while Robert Haynes telegraphed Denver and requested that an ambulance meet the train. Present-day tourists are delivered to the summit and various scenic overlooks in a wide assortment of motorized and nonmotorized vehicles.

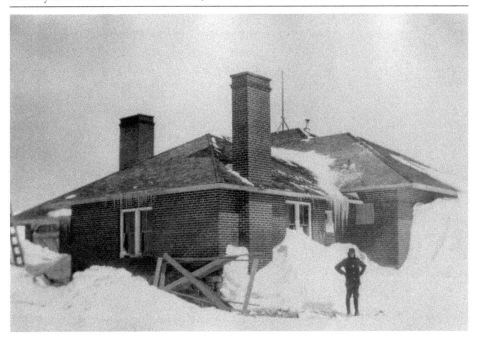

Mountain passes are not customarily named for their apex stations: Fremont Pass, not Climax; La Veta Pass, not Fir; and Rollins Pass, not Corona. The US Geological Survey and the US Board on Geographic Names recognize Rollins Pass as the official name. It is the sole listing in the Geographic Names Information System and in the Correct Orthography of Geographic Names. Area author Frederick Bauer bluntly wrote, "[Rollins Pass is] incorrectly called Corona Pass by neophytes and some locals." (Past image, courtesy of Moffat Road Railroad Museum.)

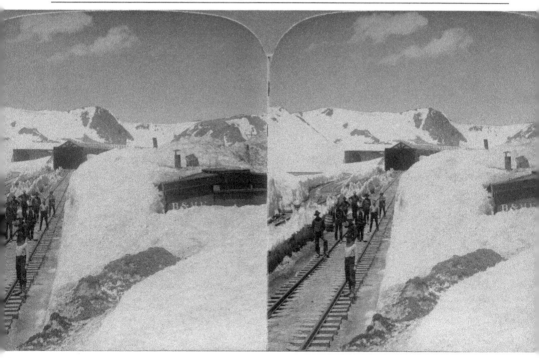

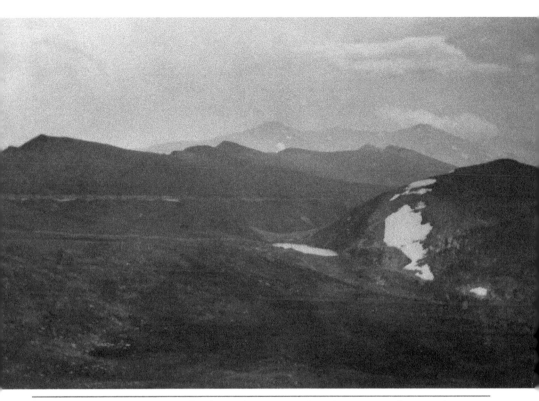

Mount Epworth, at right mid-ground, is flanked by steep slope angles, presenting dangerous avalanche terrain for backcountry travelers. On February 14, 2021, a hard slab avalanche was unintentionally triggered by a snowmobiler, who was carried into Pumphouse Lake. Approximately two miles away and nearly 20 years earlier, two skiers were caught in an avalanche and were carried into Yankee Doodle Lake; the avalanche forcefully punched through 10 inches of ice and the displaced water created a 10-to-12-foot-tall surge on the far shore.

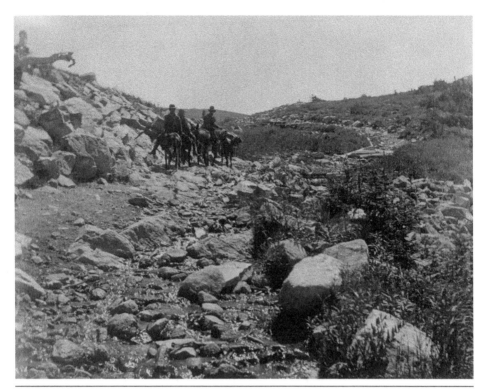

When James Harvey Crawford and Margaret Emerine Bourn Crawford made their way across Rollins Pass before settling in Steamboat Springs, Colorado, they encountered a two-hour blizzard—in June. Margaret Crawford wrote that "the bumping was so hard I thought I was nearly dead." Despite their trip taking place in 1874, the echoes of her words are heard—or felt—nearly 150 years later by many visitors to Rollins Pass. (Past image, courtesy of GCHA.)

A rotating airway beacon with course lights first appeared on sectional aeronautical charts in March 1948. "Beacon 82" was 820 miles away from Los Angeles on the Los Angeles-Denver Airway; aviation parlance typically drops zeros, hence "82." Once decommissioned, there were two attempts to move the structure by helicopter. The first attempt pulled the tower off its base, and the structure leaned toward Winter Park until a larger helicopter could transport it to Granby. The beacon still exists and is part of the Grand County Historical Association's collection. This past photograph is unique; both the FAA and the US Forest Service have no substantial records pertaining to Beacon 82 in their archives. (Past image, courtesy of the Hans and Uta Pott family.)

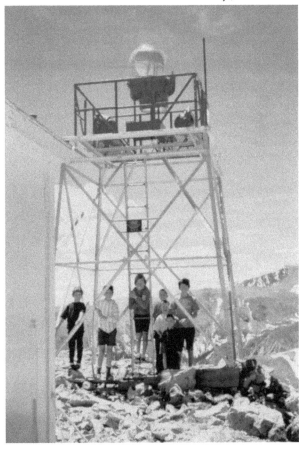

The condition of the various routes over Rollins Pass have been a recurring issue, not only in recent decades, but also predating the existence of the railroad over the pass. The *Colorado Transcript* reported on September 12, 1900, "In a few years, the Rollins [P]ass road will have to be abandoned, without something is [*sic*] done to it. Boulder, Jefferson and Gilpin [C]ounty representatives should try and get an appropriation from the state to repair it, during the next meeting of the legislature."

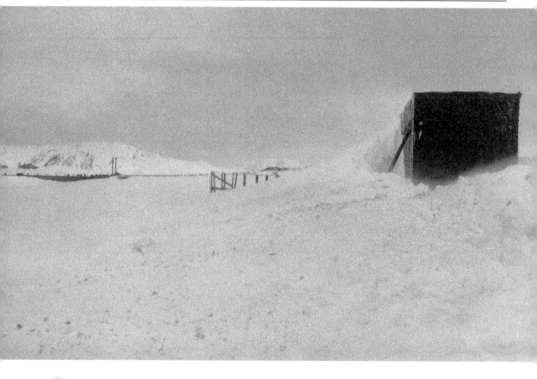

A GREAT GATE: TRAVERSING ROLLINS PASS

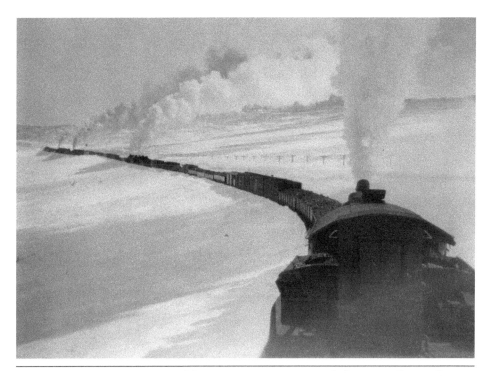

The Moffat Tunnel voided the need for scenes like this and for rails over Rollins Pass. When the Denver & Salt Lake Railway applied for permission to abandon the rail route over Rollins Pass on March 16, 1935, the request to the Interstate Commerce Commission read, "App. [*sic*] for certificate to abandon that part of its line extending from a point near Newcomb, in Gilpin County, to a point near Vasquez, in Grand County, Colorado, a distance of 31.76 miles."

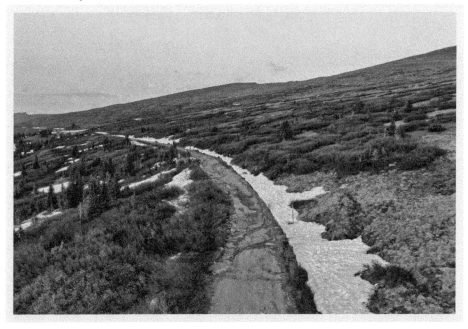

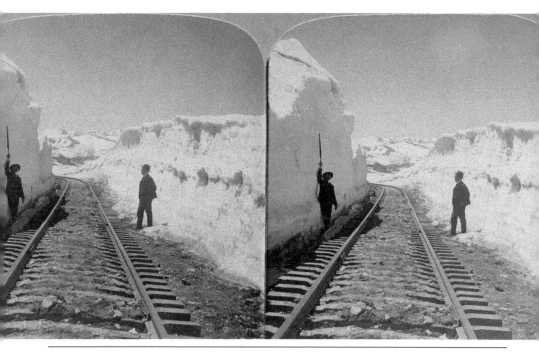

The Interstate Commerce Commission replied to the abandonment request (see prior page) on May 14, 1935: "It is apparent from the record that the line sought to be abandoned has served the purpose for which it was constructed, that its operation would impose an unnecessary and undue burden on interstate commerce, and that the proposed abandonment will not result in public inconvenience." The rails and ties were removed from Rollins Pass the following summer. (Past image, courtesy of Moffat Road Railroad Museum.)

A 900-psi (pounds per square inch) natural gas pipeline was placed across the great gate of Rollins Pass, beginning in the 1960s. The underground pipeline joins the Rollins Pass Road near Ptarmigan Point and stretches toward the summit. Directly south of the Corona townsite, the pipeline arcs east, running immediately astride congressionally-designated wilderness as it continues beside the twin trestles, then down and across Guinn Mountain. The pipeline is still in use; in the event of an emergency, call Xcel Energy at 1-800-698-7811. (Past image, photograph by Dan Micka; courtesy of Steve Pott.)

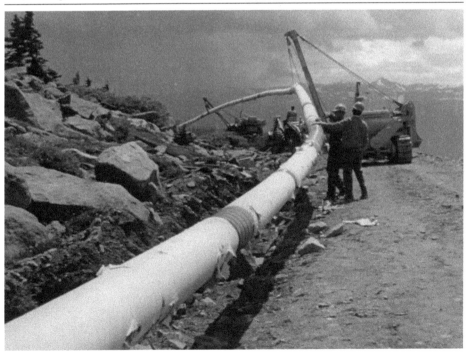

Plumes of dense, dark smoke can be seen as a train chuffs uphill toward the Loop. In the present image, curls of white smoke can be seen from the 14,833-acre Williams Fork Fire, silhouetting Byers Peak in the distance. In 2020, Grand County saw an active year for wildfires; the East Troublesome Fire became Colorado's second-largest wildfire in history at 193,812 acres—with over 120,000 heartbreaking acres consumed overnight. US Forest Service fire investigators determined both wildfires to be human-caused.

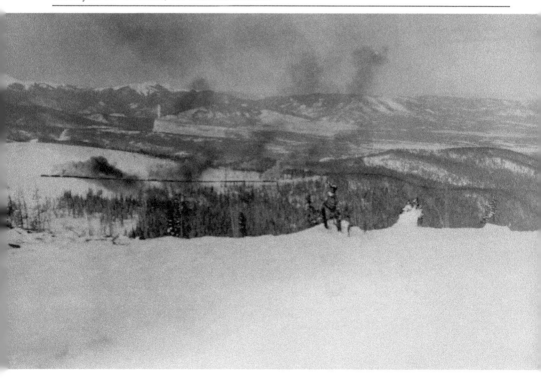

A GREAT GATE: TRAVERSING ROLLINS PASS

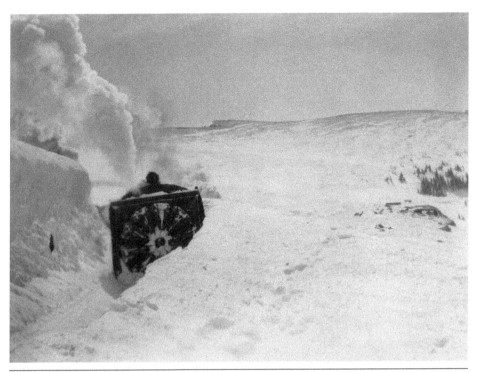

Beginning December 31, 1921, passenger service on Rollins Pass was reduced to a triweekly basis. "Heavy losses from the operation of daily trains is the reason given" posted Telluride's *Daily Journal*. Three years later, a café car was added to the passenger trains because with a full belly, the thought was passengers could stomach any delays or blockades. While the fastest time over "the Hill" was a speedy 150 minutes; the longest was an abysmal and tortuous 60 days.

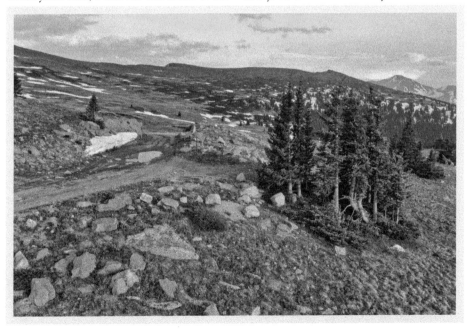

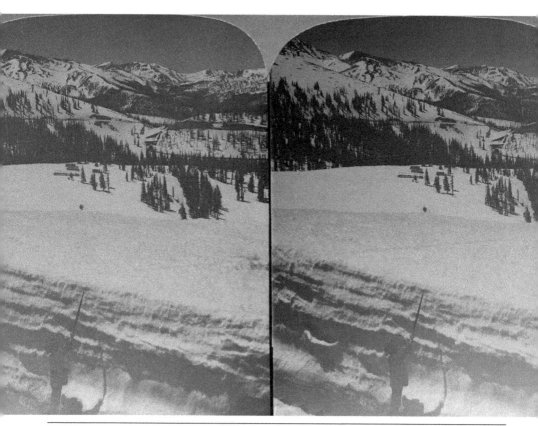

Zoologists, entomologists, ornithologists, botanists, and bryologists from Colorado State University's Colorado Natural Heritage Program, other partner agencies, and organizations studied both common and rare flora and fauna on the western portions of Rollins Pass in mid-July 2021. Documented in just four days were 30 bird species, two species of fish, five types of fungi, 29 invertebrates, 19 mammals, 50 nonvasculars (moss and lichens), 159 vascular plants, and incredibly one type of mollusk, a pisidium. A family of liverwort previously not found in Colorado calls Rollins Pass home.

A GREAT GATE: TRAVERSING ROLLINS PASS

A train glides the gentle slopes at Sunnyside, pictured below, located between Corona and the Loop. On Friday, January 12, 1917, conveyed the *Oak Creek Times*, "An engine and twelve cars got away in the absence of the crew near Corona and running down grade crashed into a light engine in the tunnel at the Loop station. The wreckage had to be removed by hand as the crane could not get at it." (Past image, provided courtesy of Tread of Pioneers Museum, Steamboat Springs, Colorado.)

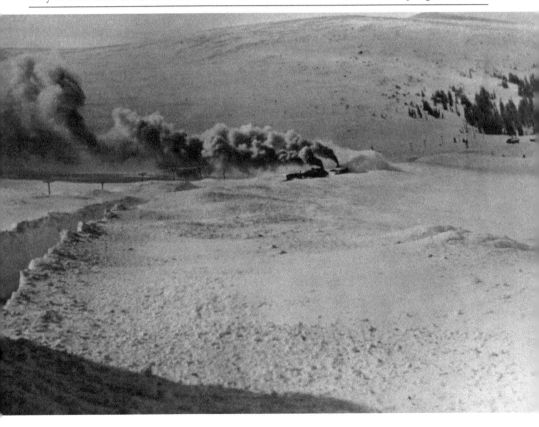

At left below, a square fence created with discarded railroad ties can clearly be seen in this 1946 US Forest Service nadir photograph. This was officially known as the Corona Range Study Plot, or "the Corona Exclosure." The plot was established in 1939. As the area was used by sheep in 1940, the first readings were delayed until 1945 and continued through 1964. The study examined bare soil, moss, litter, plant, and forage densities both inside and outside of the exclosure. (Past image, courtesy of USFS.)

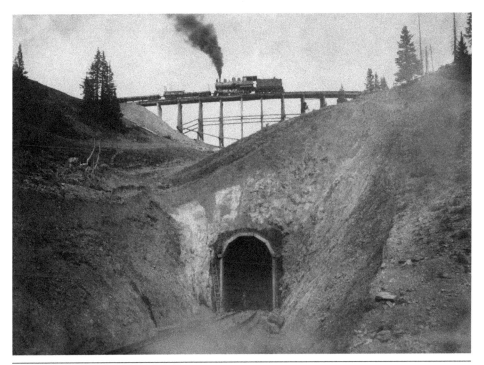

Horace Sumner's famous Loop tested both metal of locomotives as well as the mettle of men as told in the February 1, 1912, *Oak Creek Times*: "Carson Friend, a freight fireman, has a broken shoulder, the result of jumping from his engine west of Corona, because of the train running away. Engineer George Clark also jumped, but the brakeman and conductor stuck to their posts, and stopped the train at the Loop. Mr. Clark turned in his resignation upon reaching Fraser." (Past image, photograph by Charles Crocker; courtesy of the Tyler family.)

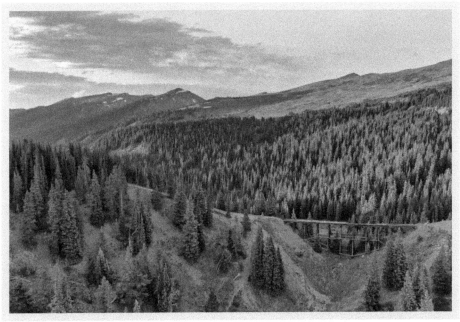

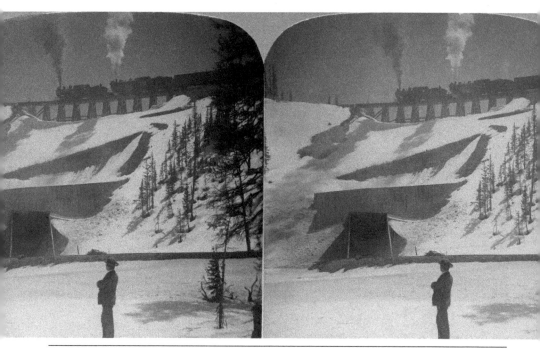

The *Steamboat Pilot* recorded this story from 1907: "Edward Eberhadt, druggist of Denver, rode horseback across country to Tolland where he followed the Moffat railroad track across Rollins [P]ass, going thru [*sic*] the tunnels and snow sheds. He stayed over night at Corona. Next day he encountered the loop with a long trestle to get over. Workmen who happened to be near shoveled a short-cut for him thru [*sic*] the snow . . . he took the old stage road into Hot Sulphur." (Past image, courtesy of Moffat Road Railroad Museum.)

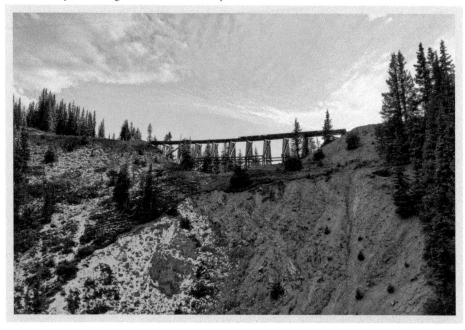

The Rails that Climb: A Narrative History of the Moffat Road by Edward Bollinger is a Rollins Pass fan favorite. Reverend Bollinger mentions the 1924 derailment of Mallet No. 210 and, on page 206, writes that "you can pick yourself a souvenir today, for some of her junk is still there." The unfortunate reality is Bollinger's recommendation now contradicts established laws that protect artifacts and sites such as the final resting place for Mallet No. 210. In the image below, an ill-timed boulder's tumble derails the downhill-bound No. 302 and its schedule.

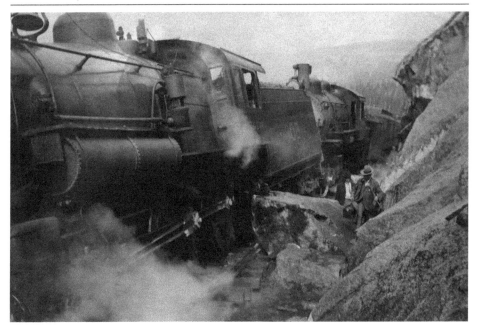

Core elements of historic integrity include setting, feeling, and location. If Moffat Road employees Edward Bollinger or John Trezise were to somehow return to Rollins Pass, they undoubtedly would recognize each bend in the road, the grade and rock cuts, locations of old foundations, and the forests below timberline. Even with the passage of time, historic integrity can still be recognized in most of the present-day images throughout this chapter.

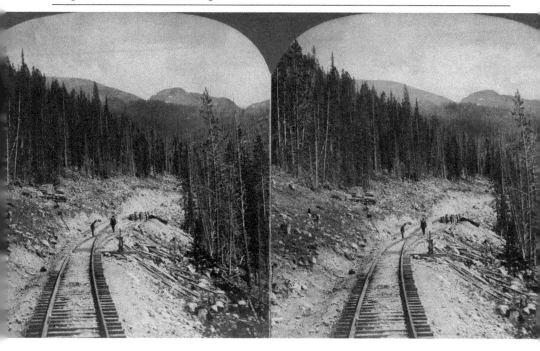

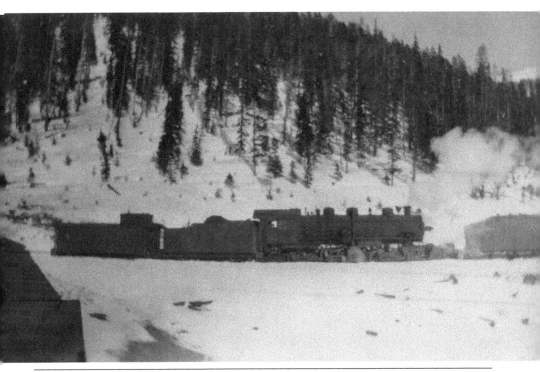

A train uses the then extant trestle that stretched across the water at Ranch Creek Wye. A 2016 US Forest Service Passport in Time archaeology project documented historic trash (can dumps) nearby in the forests—some cans are embossed with "Calumet Baking Powder"—likely a key ingredient of what may have kept the men fed while working in such harsh conditions. These artifacts are now entombed under thousands of downed trees from a September 2020 derecho.

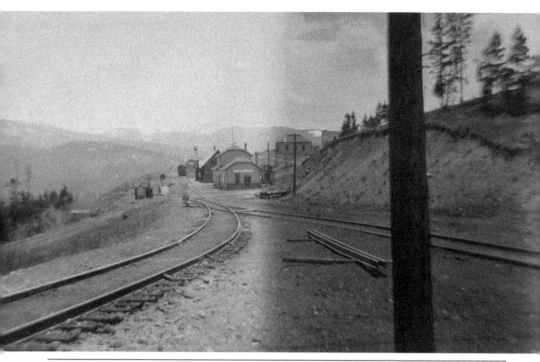

Arrow provides an amusing backdrop for anecdotes. The November 21, 1912, *Oak Creek Times* reported W.H. Sheets, an Arrow saloon proprietor, "applied for a county license to sell liquor, but was informed that the commissioners could not grant a license at Arrow because Arrow is an incorporated town. Sheets could not get a license from the town board because he could not find any town board . . . in the meantime Sheets may continue to conduct a saloon legally without paying license."

A GREAT GATE: TRAVERSING ROLLINS PASS

The Moffat Road and townsite of Arrow on lower Rollins Pass face new challenges in the 21st century. Distressingly, this national historic district is threatened by development pressures; the Town of Winter Park has identified this land as within the "three-mile planning area," and it is anticipated "this area will be annexed into the [town] as part of [a] property exchange." One federal land exchange has been attempted, and advocacy efforts as well as permanent protections are needed. (Past image, photograph by Charles Crocker; courtesy of the Tyler family.)

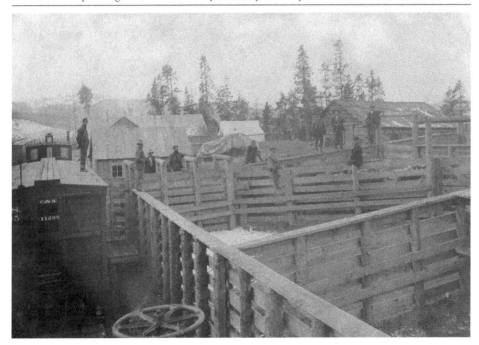

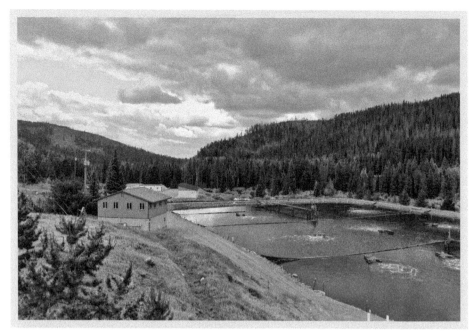

The west side of lower Rollins Pass contains the remaining boundaries for the historic Loui and Lupton Placers (pronounced "plassers") shown on historic maps, including Interstate Commerce Commission records. The initial rocky grade of Rollins Pass and the nearby Fraser River made the location ideal for alluvial extraction operations and may represent some of the earliest claims for gold in Grand County from 1882. The placers are near the W.H. Woods sawmill finishing plant at Irving Spur, now the site for the Winter Park Water and Sanitation District. (Past image, courtesy of USFS.)

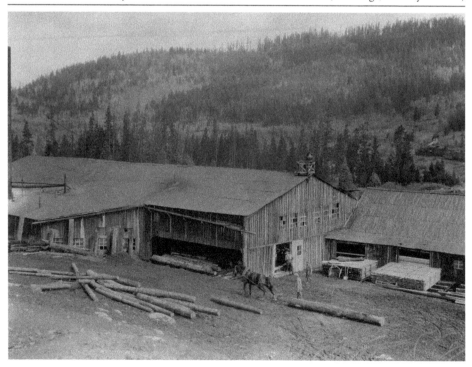

CHAPTER

3

PIERCING THE DIVIDE

THE MOFFAT TUNNEL

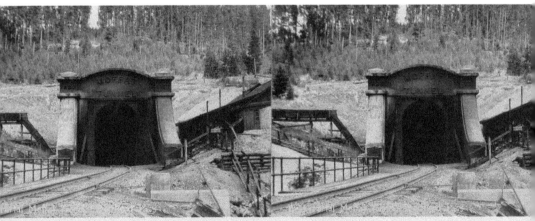

The creation of the 6.2-mile-long Moffat Tunnel through the Continental Divide was a monumental undertaking; 400 tons of drill steel were used for the 700 miles of drill holes made through the heart of James Peak. Dynamite—1,250 tons of it—loosened 750,000 cubic yards of rock for excavation, the equivalent of 1,600 freight trains, each 40 cars long. (Courtesy of Tristan Anderle.)

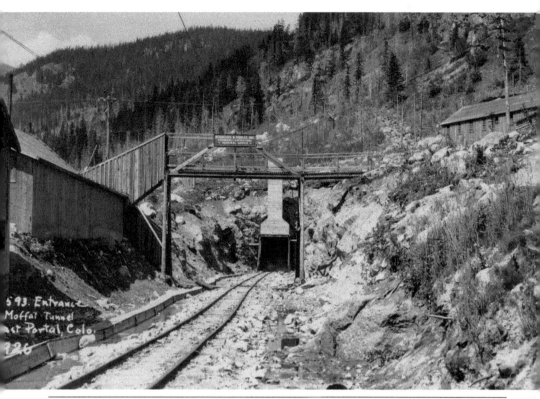

5 93. Entrance
Moffat Tunnel
st Portal, Colo.
126

The 1922 law authorizing the Moffat Tunnel "specifi[ed] that the bore should be used by cars as well as trains." Several *Steamboat Pilot* articles mention the plan was to ferry cars through the tunnel "on electric-powered railroad flatcars" and then collect a "toll charge." If such a plan were enacted, it would slash approximately 28 miles and nearly 4,000 feet of total elevation from the present route up, over, and down Berthoud Pass. (Past image, courtesy of Tristan Anderle.)

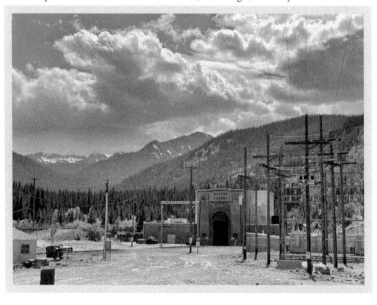

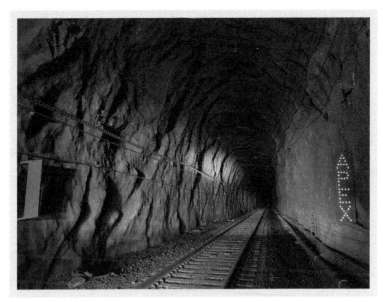

A train moving east to west through the Moffat Tunnel begins at an elevation of 9,196 feet at the East Portal, ascends a very gentle 0.3 percent grade, and 14,054 feet later, reaches the tunnel's apex at 9,238 feet above sea level. Descending the remaining 18,746 feet toward the West Portal, two different grades are encountered (0.9 percent and 0.8 percent) toward the portal's elevation of 9,098 feet. The traveler will have passed 21 refuge locations (repurposed crosscuts) on the tunnel's left side. (Past image, courtesy of the Denver Public Library, [Call Z-5677].)

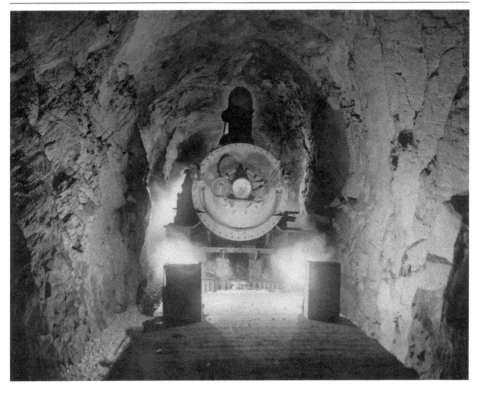

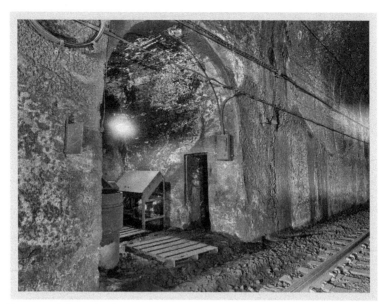

The Moffat Tunnel brought forward a new development in shift labor not used before with tunnel construction: call-shifts. Previously, schedules involved three eight-hour shifts every 24-hour period. With call-shifts, workers were "on-call" to perform a specialized task (drilling, mucking, or timbering) and were to complete the job before leaving the tunnel. Workers received full compensation, even if the task took only three hours, and would receive overtime if the job took more than eight hours. (Past image, courtesy of the Denver Public Library, [Call Z-5679].)

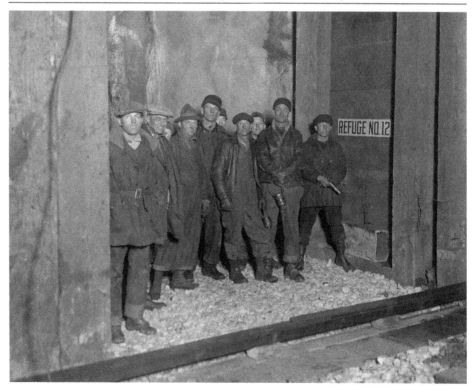

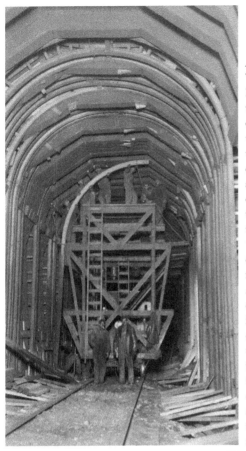

The Moffat Tunnel is a cathedral to engineering. Its simplicity occludes its sophistication, with the creation of nothing from something—the deliberate absence of rock amid incalculable weight. The finalized engineering marvel has a ventilation system that performs a complete air exchange within the tunnel in 18 minutes. The seemingly endless stone archway has intricately designed and perfectly positioned "umbrellas" to disperse alpine lake seepage to either side of the tracks. During construction, on February 15, 1925, tunneling progress stalled 1,100 feet directly under Crater Lake as 1,800 gallons per minute of water began flowing into the tunnel. At the suggestion of electrician K.S. Weston, crews ventured to the lake, cut through three feet of ice, and poured in 10 pounds of chloride of lime. Shortly thereafter, the presence of lime was detected inside of the tunnel. In an attempt to close the seam, a stick of dynamite was tossed into the lake, and the flow rate dropped drastically to 150 gallons per minute and then slowed to a trickle. Multiple times per day, the visceral vibration of mechanical thunder reverberates through the bowels of the earth.

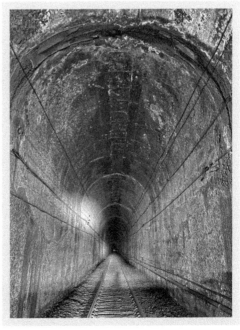

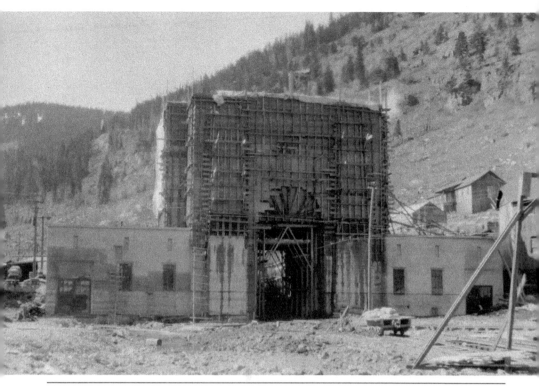

The East Portal company town had a 24-hour mess hall serving high-quality food, a six-bed hospital with an operating room and x-ray machine, a movie theater (admission was 35¢), women's bridge clubs, a post office, and a school. The whole operation was dry—the Moffat Tunnel was built entirely during Prohibition—and the town of East Portal is one of the few communities in early Gilpin County without a saloon. (Past image, courtesy of the Gilpin County Historic Preservation Commission.)

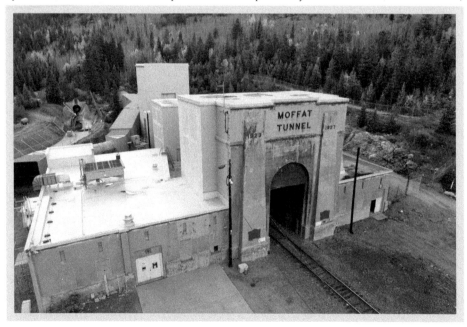

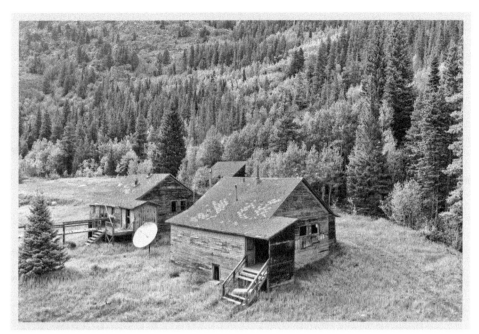

At East Portal, the most specialized buildings such as the compressor house, machine shop, and powder magazine, all located closest to the tunnel entrance toward the south, were demolished first. The most adaptable buildings continued to be used through the early 2000s as housing for workers who helped maintain the Moffat Tunnel. This solves the mystery for those trying to reconcile the buildings' historic use and yet see a sizable, aged satellite dish outside of the cottages. (Past image, courtesy of the Gilpin County Historic Preservation Commission.)

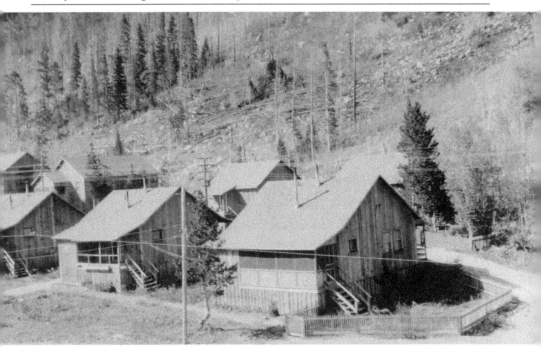

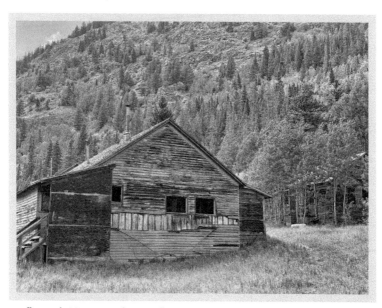

An American flag with 48 stars can be seen flying from the paymaster's home at East Portal in the photograph from July 4, 1924. The five remaining cabins at East Portal were listed in 2020 as one of Colorado's Most Endangered Places by Colorado Preservation Inc. While Mother Nature and Father Time exert tremendous forces on the outside of these structures, heartbreaking vandalism seeks to shatter these buildings from within. The West Portal held 200 more workers, yet none of the historic structures remain. (Past image, courtesy of the Gilpin County Historic Preservation Commission.)

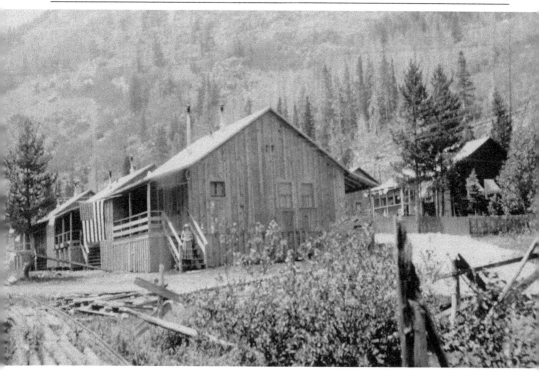

PIERCING THE DIVIDE: THE MOFFAT TUNNEL

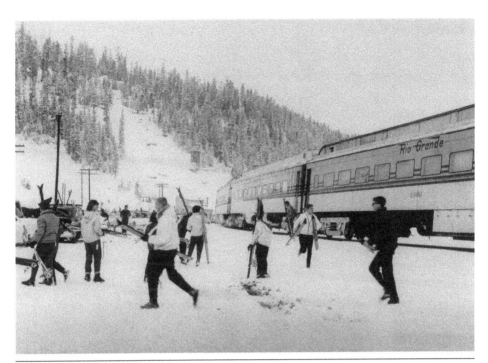

Tourists are transformed into skiers as if by Moffat Tunnel magic: tracks are mere steps away from chairlifts at Winter Park Resort. The first ski train ran in 1940 and was subsequently replaced by Amtrak's Winter Park Express. In the present image, conductor Brad Swartzwelter assists a traveler with her skis. Nearby, skiers can use and appreciate the 1955 historic Balcony House listed in 2021 as one of Colorado's Most Endangered Places by Colorado Preservation Inc. (Past image, courtesy of GCHA; present image, photograph by Alex Funderburg.)

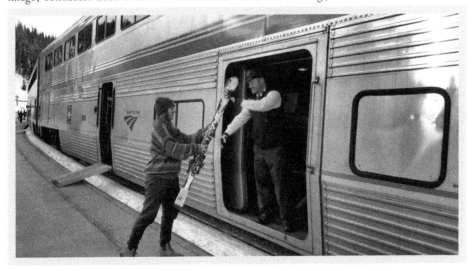

BIBLIOGRAPHY

Alford, Paul. Yankee Doodle Lake OHV Repairs Project Monitoring and the Preliminary Testing of 5BL370.1. US Forest Service: Arapaho and Roosevelt National Forests and Pawnee National Grassland, 2008.

Anderson, David, and Susan Panjabi. "Rollins Pass Bioblitz." Interviews by authors. March 2021–February 2022.

Colorado Preservation Inc. "Rollins Pass Land Exchange Opposition." Interviews by authors. October 2020–April 2021.

Griswold, Phelps R. *David Moffat's Denver, Northwestern and Pacific: The Moffat Road*. Denver, CO: Rocky Mountain Railroad Club, 1995.

LaBelle, Jason. "Rollins Pass Archaeology." Interviews by authors. December 2012–November 2021.

McMechen, Edgar Carlisle. *The Moffat Tunnel of Colorado: An Epic of Empire*. Denver, CO: The Wahlreen Publishing Company, 1927.

Lemon, Josh. "Moffat Tunnel Modern-Day Operations." Interviews by authors. September 2021.

Norton, Holly. "Historic Preservation of Rollins Pass." Interviews by authors. March 2021–September 2021.

O'Dorisio, Steve. "Old Camp and Ladora History." Interviews by authors. May 2019–November 2021.

O'Leary, Rich. "Ladora and Zarlengo Family History." Interviews by authors. June 2021–November 2021.

Pott, Steve. "Pipeline Infrastructure and Safety." Interviews by authors. October 2021.

Ransom, Lauren. "Challenges of Rollins Pass." Interviews by authors. July 2019–September 2021.

Toll, H. Wolcott. "Tolland and Toll Family History." Interviews by authors. August 2019–November 2021.

Wolfenbarger, Deon, and Tami Archer. "Section 106 and Historic Preservation." Interviews by authors. April 2019–November 2021.

Zarlengo, Bob, and Zarlengo family. "Ladora, Old Camp, Tolland, and Zarlengo Family History." Interviews by authors. July 2019–July 2021.

About Preserve Rollins Pass

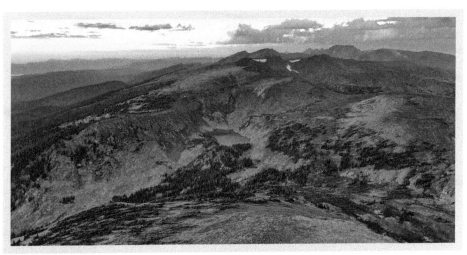

Preserve Rollins Pass strives to fulfill a Native American adage: "In every deliberation, consider the impact of decisions on the next seven generations." As one of Colorado's Most Endangered Places, prehistoric and historic preservation of Rollins Pass is paramount. Through partnerships with state and federal representatives, Native American tribes, special interest groups across the nation, archaeologists, historians, and university professors, Preserve Rollins Pass applies strategic pressures to protect the integrity of this national historic district. Credited for their professional facilitation, negotiation best practices, and ability to deliver a "master class on how to make a point," Preserve Rollins Pass makes the case for preservation, delivered through breathtaking videography and photography, modern marketing, technology, and presentation skills. These efforts—combined with public outreach, education, and field archaeology—have culminated in the collapse of significant threats to the area, including a proposed federal land exchange involving Rollins Pass. Cofounder B. Travis Wright, MPS, is a 2022 Colorado Preservation Inc. State Honor Award recipient for his advocacy of Rollins Pass, is president of the board of the Grand County Historical Association, and is vice chair of the Gilpin County Historic Preservation Commission. To learn how to help advance historic preservation of this incredible and non-renewable resource containing 12,000 years of history, please visit preserverollinspass.org. The primary purpose of this work is to inform the public.

Discover Thousands of Local History Books
Featuring Millions of Vintage Images

Arcadia Publishing, the leading local history publisher in the United States, is committed to making history accessible and meaningful through publishing books that celebrate and preserve the heritage of America's people and places.

Find more books like this at
www.arcadiapublishing.com

Search for your hometown history, your old stomping grounds, and even your favorite sports team.

CPSIA information can be obtained
at www.ICGtesting.com
Printed in the USA
LVHW070107170522
718864LV00010B/4